The Colored Pencil

REVISED EDITION

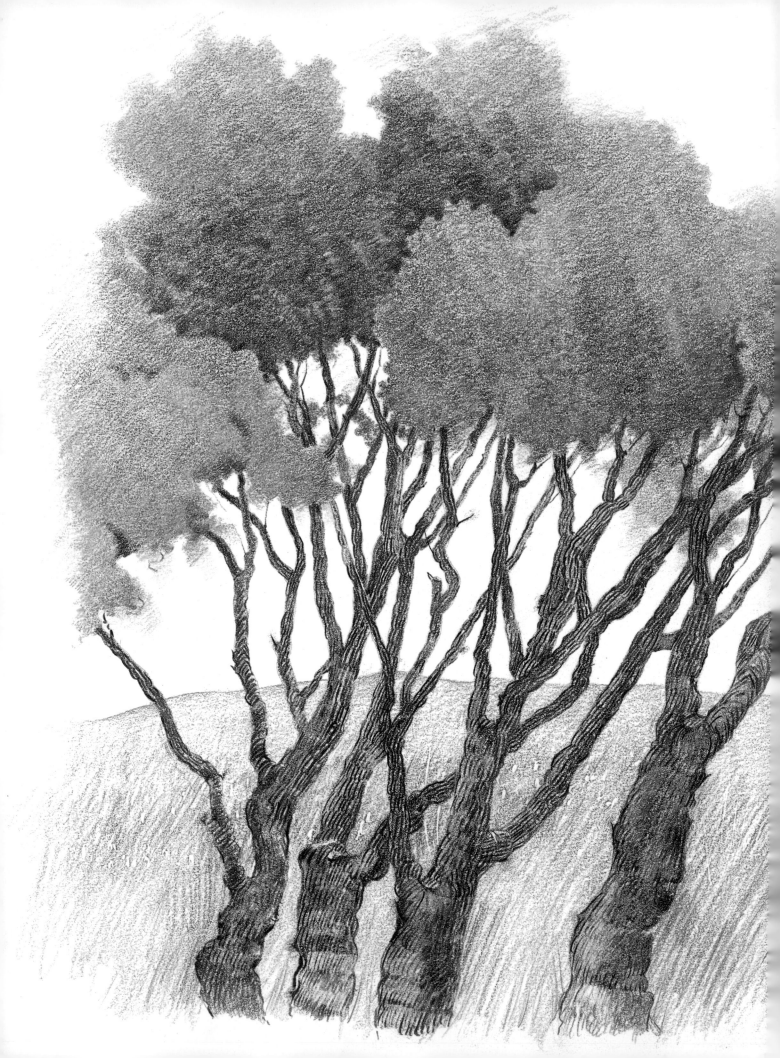

The Colored Pencil

REVISED EDITION

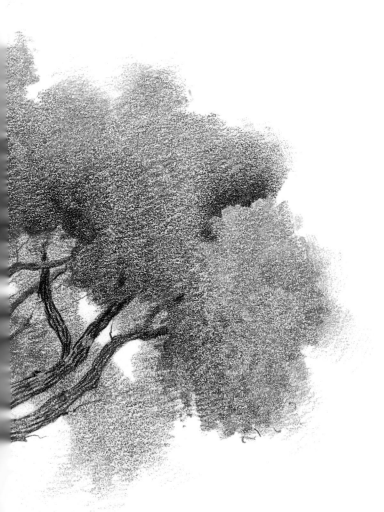

Bet Borgeson

Photographs by Edwin Borgeson

Watson-Guptill Publications/New York

Copyright © 1993 Bet Borgeson

First published 1993 in New York by Watson-Guptill Publications,
a division of BPI Communications, Inc.,
1515 Broadway, New York, N.Y. 10036

Library of Congress Cataloging-in-Publication Data

Borgeson, Bet.
 The colored pencil / Bet Borgeson.—Rev. ed.
 p. cm.
 Includes index.
 ISBN 0-8230-0748-0
 1. Colored pencil drawing—Technique. I. Title.
NC892.B67 1993
741.2′4—dc20 92-43958
 CIP

Manufactured in Singapore

Revised Edition, First Printing, 1993

1 2 3 4 5 6 7 8 / 00 99 98 97 96 95 94 93

Edited by Candace Raney and Marian Appellof
Designed by Jay Anning
Graphic production by Ellen Greene and Hector Campbell
Text set in 11-point Memphis Light

Contents

Acknowledgments

Many thanks are due to many people for their direct and indirect contributions to this effort. There are the artists— Martha Alf and Rosalinda Kolb of California; Esky Cook of Maryland; Bob Conge of New York; George L. Venable of Washington, D.C.; and Jim Hibbard, Will Martin, Ann Munson, and Julie Rall of Oregon—all of whom helped to show the possibilities of this modern medium with their breadth of styles.

I would like to particularly thank artist Rhonda Farfan of Oregon, for it was she, to the best of my knowledge, who first discovered that a minor side effect of using frisket film could be developed into the extremely valuable new colored pencil technique described in chapter eight.

I would like also at this time to again thank the late Richard Muller, who as a professor of art at Portland State University introduced me to the notion that color in art is not an ornament but a hard-working element—and that this seemingly simple idea is worth a great deal of study and contemplation.

Finally, I want to thank Paul Gropman, who as a dreamer, a storyteller, and a longtime friend of my husband and myself, has always been a foe of trying too little.

Introduction to the Revised Edition

At the time of the original publication of *The Colored Pencil* in 1983, the use of colored pencils as a fine art medium seemed to be just beginning. It was hoped then that creating and providing a body of concepts and a vocabulary specific to this medium in one sourcebook would help artists discover the wonders of the medium itself, and at the same time trigger a process of evolving new techniques. This has indeed happened, and this revised edition of the book reflects many of the dynamic changes that have occurred over the past ten years.

While continuing to include the key concepts and techniques for using colored pencils successfully, the first part of this revision also remains based on the premise that sound techniques must grow out of an understanding of the physical properties of a medium. For this reason, the first part of the book deals again with the pencils themselves. It includes the ways in which various brands differ from one another and from graphite pencils; the effects these differences can have on colored pencil capability and handling are enormous.

The first part also sorts out the basic materials needed to start working with colored pencils. A new Prismacolor palette has been added, as well as eight new color plates of finished art and illustrations. And because color is so obviously an inherent factor in the use of colored pencils, the first part also touches on the nature of color and features four new color plates. It stresses a *colorist* approach to drawing, which means that color is a key

consideration from the very beginning of a drawing—an aid to the construction of form and space, not something tacked on later as decoration.

The second part of the book deals at length with the ways in which the physical characteristics of colored pencils become a basis for the strategies and techniques for using them. Two important new chapters have been added, both of which offer techniques for lifting color easily. These methods enable artists to erase, lighten, draw negatively, and create texture in previously applied colored pencil work. Accompanying all the techniques in this second part are detailed illustrations, thirty-nine new color plates, and thirteen step-by-step drawing demonstrations.

No single approach to style is advocated, however, and illustrations throughout this book of finished artwork by various artists reflect a broad range of expression and intent. In some cases, small sections of drawings are shown in magnified detail to reveal more exactly what is happening on the paper's surface.

As a final note, it is of more than ordinary importance with colored pencil work—where color and texture changes are swift and subtle—that the visual and tactile effects of pencil pressure, hue layering, and paper surface be personally experienced. Fortunately, the nature of this remarkable medium makes this neither a difficult nor an intimidating task. It is sincerely hoped, therefore, that from the very beginning your use of this book will be with your own paper and pencils close at hand.

The Colored Pencil Medium

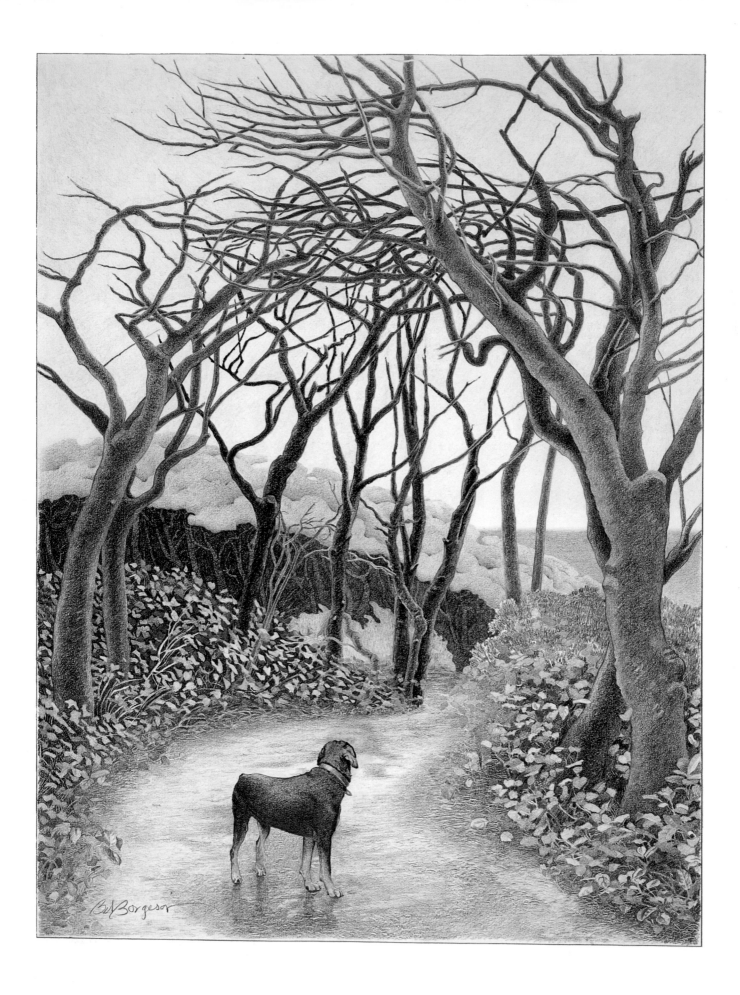

1
Getting Acquainted with Colored Pencils

In terms of traditional art, there is a feeling of newness about colored pencils, even though the idea behind them is not new at all. The desire to fashion a convenient drawing tool combining a colored chalk or crayon with a wood shaft goes back at least to the Renaissance.

Today's colored pencils are descendants of natural chalk. Red chalks were a favorite of artists as early as the fifteenth century, although black and white and a few other colors were also used. These natural chalks were sawed and whittled into sticks, inserted into hollow reeds—frequently with a different colored chalk at each end—and fastened in place with strips of cloth or leather thongs. It was common practice for the chalk sticks to be sharpened to very fine points, and artists such as Leonardo, Michelangelo, and later, Antoine Watteau, among others, became masterful with them.

This same early period also witnessed, along with the use of natural, and later fabricated chalks, the development of the fattier

(opposite page) Bet Borgeson, Looking Back, *1989. Colored pencil on Rising museum board, 19½″ × 26″ (49.5 × 66 cm). Courtesy of the artist. A feature of colored pencil artwork is that it has the capacity of expressing two drawings in one. There is the overall image, with its simple masses of color projecting ten feet or more, and there is the closeup version (detail right), revealing a finer web of color nuances.*

"true crayon." Leonardo himself cited a recipe for it. A lot of such recipes began to appear, and by the end of the eighteenth century the beginning of colored pencils was clearly in view. For at this time, according to James Watrous in *The Craft of Old Master Drawings*, "Thomas Beckwith an artist of the city of York patented a method of making crayons with 'dephlegmated essential oils' and 'animal

oleaceous substances' which were also fired and then fitted into grooved pieces of wood."

What is new about today's colored pencils—as developed and refined during the past sixty years—is not the basic idea of them. What is fresh, and indeed exciting about them, is their present-day ability to so successfully and consistently deliver the long-sought goal of combining the color of crayon with the handling ease of a wooden shaft.

Excellent quality colored pencils—inexpensive yet sophisticated marvels of crayonlike material encased in wood—are now produced by a number of manufacturers, both foreign and domestic. Although not all are made for art uses, most contain four general categories or ingredients: the pigment—organic and inorganic—which gives them color; the binders, to hold the material together and give it strength; the clays, which serve as opacifiers; and the waxes, which aid in smoothness of application. Variations in the amounts and nature of these things depend on the hues and hardnesses desired and the uses for which a particular type of colored pencil is made.

The important thing for an artist to remember when choosing a brand of colored pencils is that they perform well for a specific need. The uses for which a manufacturer intends its pencils can often be deduced from the product's packaging or display rack information. Ultimately, however, the artist's personal experience will become the surest guide.

As a beginning, some of the qualities a fine-art colored pencil must have are:

1. Permanence of pigments.

2. Good "lay-down," which means that the pigment builds quickly, uniformly, and vividly, with no feeling of grittiness, no squeak.

3. Excellent hue saturation, strength of color.

4. Consistency of construction quality: firmly set leads, good general craftsmanship.

What You Will Like About This Medium

Colored pencils are unintimidating and inexpensive. You can make a start with them almost on a whim. There is neither the burdensome investment in materials and equipment nor the spiritual weight of responsibility that a heavy cash investment can sometimes bring. Because the price of exploring the medium is minimal—even using the best colored pencils—you can afford to make a lot of drawings without the fear of high costs.

Working with the medium is uncomplicated. It will not worry you with a bewildering array of exotic appurtenances and paraphernalia. You won't need any special changes in setup or studio space. All you'll need to begin is a tablet of paper, a sharpener, and some pencils.

Colored pencils are clean to use, and the need for cleanup time after a drawing session is just about nonexistent. Also, the materials store easily and do not deteriorate with age.

But these are only the small and practical things. What is truly exciting about the colored pencil medium is the aesthetic freedom it offers. The combination of qualities can deliver a precision of line akin to that of a graphite drawing pencil and can also swiftly establish large areas of color in the manner of a crayon. Colored pencils can, in fact, and almost simultaneously, evoke either drawing effects or painting effects—or both such effects combined.

Another unique feature of this medium is its potential for expressing two drawings in one. The first is the drawing that projects across a room, its subject and large shapes of color engaging the viewer. The second, more intimate drawing becomes apparent only as the viewer moves in close enough to see the nuances of subtly layered, juxtaposed, and textured color for which this medium is becoming best known.

Lastly, there is very little restriction about the drawing surfaces to which colored pencil can be applied. Besides paper, colored pencils work well on a gesso ground, cotton and linen, wood, and matte-surfaced plastic film.

Rosalinda Kolb, Life and Death Are Not Two Things But Two Wings, 1980. _Colored pencil on colored paper, 30" × 44" (76 × 112 cm). Courtesy of the artist._
In this colored pencil drawing, executed solely with linear technique, a quality of movement and flight is held in balance by the unifying stability of a colored paper surface. It is an excellent example of technique used as a means toward an aesthetic end, rather than as an end in itself.

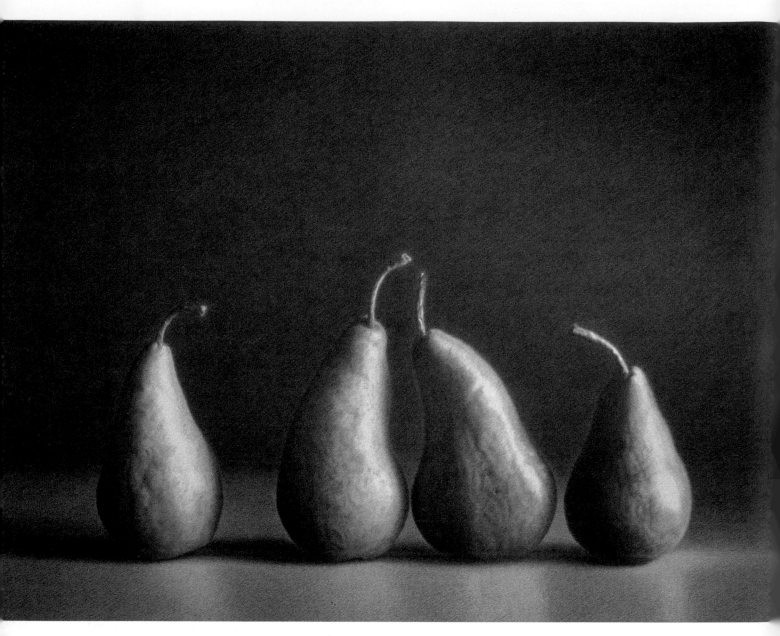

Martha Alf, Four Bosque Pears Chiaroscuro, 1989. Colored pencil on Arches paper, 30" × 22¼" (76.2 × 56.5 cm). Collection of Mr. and Mrs. Russel Kully, San Marino, California. Courtesy of Newspace, Los Angeles. In this work the artist used Verithin colored pencils, made by Empire Berol USA. This brand of pencil has a harder and thinner lead than Berol's Prismacolor line.

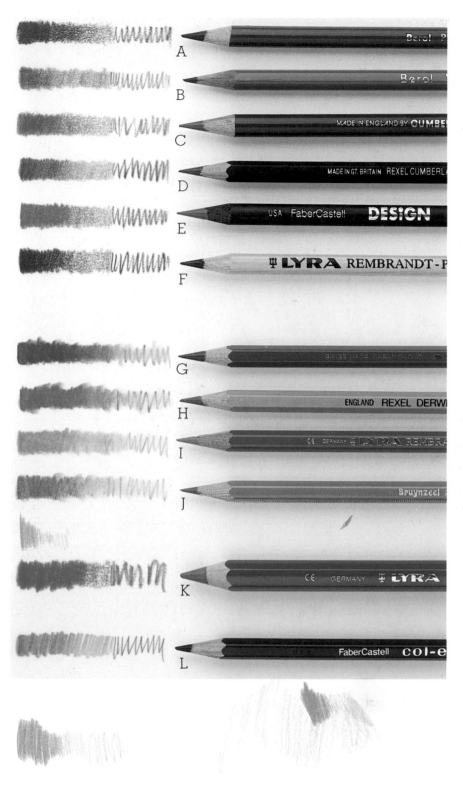

Personal experience is the best guide to finding the brands of colored pencils most useful to you. Another consideration is whether or not a particular brand is available in open stock as well as in sets. You may ultimately use a combination of brands. Here are some of the pencils now available:

A. Empire Berol Prismacolor (USA). Excellent smooth and buttery "lay-down"; superior hue saturation; soft, thick leads. This pencil is wax-based and not water soluble. Widely available.

B. Empire Berol Verithin (USA). Compared to A, leads are thinner and harder; hues less saturated; application less granular.

C. Rexel Cumberland Derwent Artists (Great Britain). Drier and harder than A; application less granular; wax bloom less likely. Spotty availability.

D. Rexel Cumberland Derwent Studio (Great Britain). Drier and harder than A. More widely available than C.

E. FaberCastell Design Spectracolor (USA). In many ways, very similar to A.

F. Lyra Rembrandt-Polycolor (Germany). Silky lay-down, with extremely soft leads that can be rubbed somewhat. Oil-based, so has no wax bloom problem.

G. Caran D'Ache Supracolor II Soft (Switzerland). Water soluble; velvety (not buttery) lay-down; colors more intense when used wet.

H. Rexel Cumberland Derwent Watercolour (Great Britain). Similar to G. Only pencil in this aqueous group of four with named colors; other brands numbered only.

I. Lyra Rembrandt Aquarell (Germany). Similar to G, but with less tinting strength.

J. Bruynzeel Aquarel (Holland). Very soft pencil, similar to G.

K. Lyra Farb-Riese Color Giant (Germany). Hefty sized pencil limited to 18 unnamed colors. Handles much like other wax-based pencils. Needs special oversized sharpener.

L. FaberCastell Col-erase (USA). Hard, thin lead; weak hue saturation.

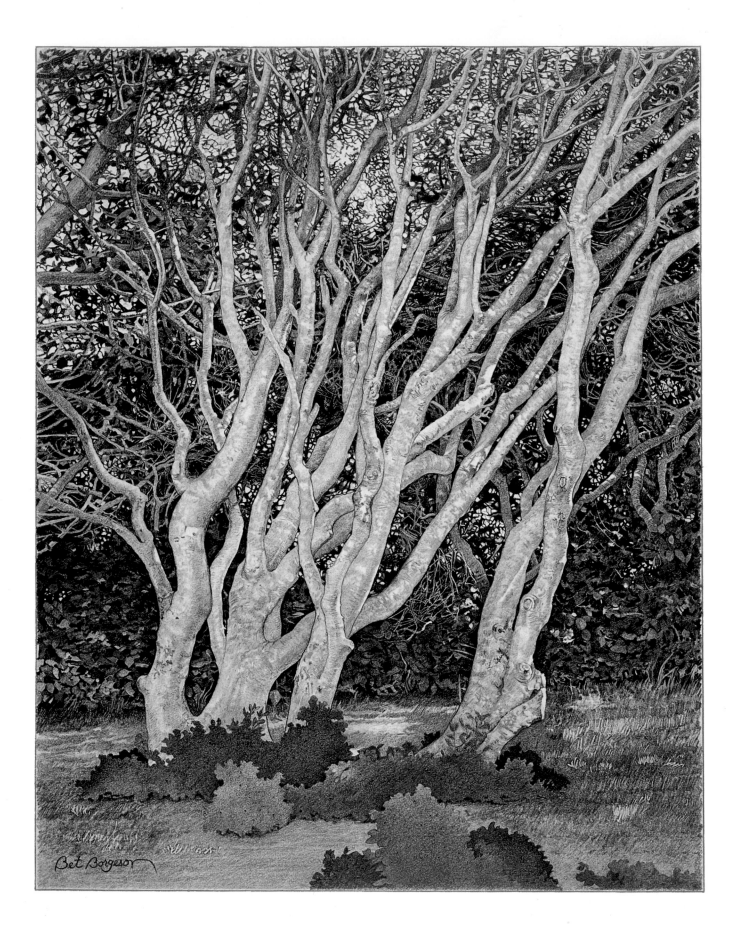

2
Materials: Getting Started

There is an exhilaration about setting up with new materials. It promotes energy, promises a fresh start, and inspires new ideas. And gathering the materials you will need for a good start in colored pencil drawing is not a difficult chore. With the list that follows, you will be able to explore all the techniques discussed in this text and also to try some experiments on your own. What you basically need are:

an assortment of art-quality colored pencils

a sharpener

drawing paper

Art Stix

a graphite pencil

two erasers

frisket film and burnishers

drafting or masking tape

pencil extenders

some small empty jars

fixative

a drawing board and a light

(left) Bet Borgeson, Yaquina Bay Trees, 1990. Colored pencil on Rising museum board, 19" × 24" (48.3 × 61 cm). Private collection. In this drawing, color saturation as well as detail were accomplished by use of a medium-grained museum board as a drawing surface.

But there are a few things to consider before you set out to purchase these materials.

An Assortment of Art-Quality Colored Pencils

Pencil manufacturers seldom designate hues with the same traditional names (such as cadmium red light) as do manufacturers of artists' oil, acrylic, and watercolor paints. Nor are the names and numbers of colored pencil hues standardized from brand to brand. One manufacturer's "peacock green," for example, may vary in hue from another manufacturer's "peacock green." In order to standardize hue designations in this text, all numbers and names will be those of the Prismacolor pencils made by Empire-Berol USA. This brand is currently in wide use among professional artists and is available almost everywhere.

Although Prismacolor currently offers 120 colors, you will not need anywhere near this amount at the beginning. The following assortment of pencils will furnish you with a more than adequate start at representing the colors of the spectrum and will serve as a basis for mixing many additional hues:

Blues:
901 indigo blue
902 ultramarine
903 true blue
904 light cerulean blue
919 non-photo blue
933 violet blue

Greens:
907 peacock green
908 dark green
909 grass green
910 true green
911 olive green
912 apple green
913 spring green

Yellows, Reds, Violets:

914 cream
916 canary yellow
917 sunburst yellow
1003 Spanish orange
918 orange
921 pale vermilion
922 poppy red
923 scarlet lake
924 crimson red
926 carmine red
929 pink
931 dark purple
932 violet
956 lilac

Earths:

937 Tuscan red
942 yellow ochre
943 burnt ochre
947 burnt umber
948 sepia

Neutrals:

935 black
938 white
949 silver
1054 warm grey 50%
1050 warm grey 10%
1063 cool grey 50%
1059 cool grey 10%

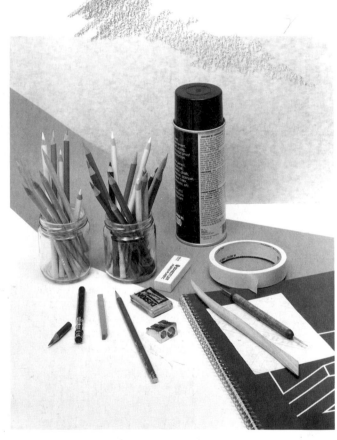

The basic materials needed for a good start in colored pencil work are (clockwise): an assortment of art-quality colored pencils (organized here into two small jars); an aerosol can of workable matte fixative; masking tape; a piece of frisket film and a couple of burnishing tools; a tablet of medium-grained drawing paper and a few loose sheets of paper with varying textures; two erasers (white plastic for light erasing, kneaded for lifting pencil material); a handheld pencil sharpener; an HB graphite pencil; an assortment of Art Stix (only one shown); and at least one pencil extender (shown here with a stub of still-usable colored pencil).

It is worth noting that the progression of these pencil numbers does not necessarily indicate an orderly, systematic progression of hue, as on a color wheel. The hue 918 orange, for instance, is not followed, as might be expected, by an orange-red hue. Instead, it is followed by a blue, with the designation 919 non-photo blue. Which merely means that your colored pencil palette cannot be planned by the manufacturer's numbering system, but must be organized by the actual hue each pencil produces.

When buying colored pencils, it is a good idea to form the habit of inspecting the pencil end for a well-centered lead, because an off-centered lead may never sharpen properly. Another precaution against sharpening problems is to protect your pencils from dropping or rough handling, which can fracture a lead within its wooden shaft.

A Sharpener

A good sharpener is a valuable tool. Because maintaining the exact degree of sharpness or bluntness is very important in colored pencil work, a convenient method of sharpening must be found. If a comfortable sharpening method is not found from the beginning, one of two things is likely to happen: sharpening your pencils will become a task to delay, leading you to attempt work with too dull a point; or stopping to sharpen your pencils will bring your work flow to a dead stop. Either situation will cost you frustration and possibly even disappointing results. For good colored pencil work, it is essential that an effort-free sharpening method be integrated into the drawing process.

There are two basic sharpening tools, and the one you choose will depend to some extent on your own temperament and working needs:

1. The small handheld sharpener provides a uniform and precise point. It is a fairly swift and unobtrusive method for getting crisp and delicate lines and for blending subtle tones together. It is also very portable. For best results, it is necessary to frequently replace the dull blades with fresh ones.

2. A rotary-action pencil sharpener—manual or electric. Just make sure it doesn't eat waxy

pencils. This sharpener would be a good choice if portability is not a consideration or if the initial price is not a factor.

When buying colored pencils, it is a good idea to inspect their ends for well-centered leads. An off-centered lead may never sharpen properly.

Drawing Paper

Almost any kind of paper can be used with colored pencils, but the paper's surface grain or texture will greatly influence the results. Although smooth paper is generally considered best for precise drawing and rough paper is more suitable for broad or loosely conceived work, it is not a good idea to base paper selection on this notion alone. When you are working with colored pencils, various other factors are involved. For example, a smooth, or plate-finished, paper will indeed yield a delicate silky line, but it does so only at the cost of a reduction in intensity. On the other hand, a medium-grained paper will yield almost as much precision of line, but the color remains strong.

In most instances, a smooth-grained paper is less satisfactory for colored pencil work than a paper of coarser grain. The reason for this can be explained by the composition of paper itself. Paper is composed of tiny interwoven fibers, which act much like a file grinding off particles from a pencil's lead. And although a smooth paper is capable of removing enough lead for a very fine line, it cannot remove enough to project a strong sense of color. To do this, a paper must be capable of removing more pencil material.

The best surface for colored pencils is one of medium grain. An irregular surface, with no obvious grain pattern, is almost always more satisfactory when neutrality of effect is wanted, than is a paper with a noticeable repeating pattern, such as vertical stripes where every fifth line is wider or an obvious pebble surface. There are, of course, exceptions to this rule, such as when a paper of distinctive surface is deliberately intended to show through as part of a drawing's total effect.

The strength of the paper is an important consideration when working with colored pencils. Paper must always be resilient enough to withstand the buildup of multiple layers of pencil; and in some cases, it must also be strong enough to bear up under techniques that are dependent on the scraping and scoring of the paper's surface.

A good all-around paper for practicing with colored pencils is the white Strathmore 400 Series *drawing* paper. It is widely available and can be purchased at a moderate price in tablets and individual sheets.

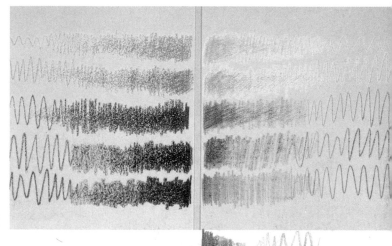

The importance of paper surface to colored pencil work can be seen in these examples of colored pencil applied to a medium-grained paper (left) and to a smooth, plate-finished paper (right).

On the medium-grained paper, the quality of these Prismacolor pencils remains soft; on the smooth-grained paper, it appears hard. The strength and richness of pencil hues are excellent on the medium-grained paper. On the smooth paper, the color strength appears decreased. A full-value range is also expressed on the medium paper, but on the smooth paper the darker values are not well achieved. There is a good blending of tones on the medium paper, while on the smooth paper, pencil strokes do not blend well.

Although smooth-grained paper can serve well with some linear techniques, a medium-grained drawing paper provides a much better surface for most colored pencil uses.

Art Stix

This is a broad stick version of the Prismacolor colored pencil. It is useful for covering large areas of a drawing's surface rapidly. It can be used alone or in combination with colored pencils.

A Graphite Pencil

The medium-grade HB or B graphite drawing pencils are useful for preliminary work. You will need them for thumbnail roughs and value studies, and they can frequently be used for lightly blocking in shapes before a drawing is begun in color. Surprisingly, the graphite tones can also double as a hue. In this role, the graphite pencil yields a somewhat greenish, almost neutral, appearance similar to a kind of green often found in nature; it can often furnish exactly the crisp delineation needed for a leaf edge. Graphite, however, does have a metallic quality, and this can register unpleasantly among adjoining colored pencil hues if it is not used discreetly.

Two Erasers

Unlike graphite pencils, most colored pencils do not erase easily or completely. This is particularly true when heavy pencil pressure is used, or when large areas need erasing. For cleaning white areas within a drawing, and for all margins, a white plastic eraser is useful. But to lighten colored pencil areas by lifting out a top layer of pigment from the paper's surface, a kneaded eraser is recommended. This eraser can be pulled and compressed to shape and thus fitted to almost any area. In colored pencil work, as in charcoal work, the kneaded eraser also functions as more than an eraser. Not only can it quickly lighten and change the character of values, but also it can serve as a constant aid in creating lightness and darkness as needed for modeling form.

Frisket Film and Burnishers

Frisket film is a generic name for various brands of a low-tack clear and/or translucent film that can be used to lift colored pencil pigment material. Burnishing tools—store-bought or hand-fashioned—are used in this technique.

Drafting or Masking Tape

This tool has many obvious and indispensable uses in the studio. With colored pencils it plays a special role: it can be used to lift off layers of heavily applied pencil pigment from a drawing's surface. When other methods fail, drafting or masking tape can accomplish the nearly impossible, sometimes with the added benefit of creating some needed texture.

Pencil Extenders

Pencil extenders or lengtheners are usually available as a wooden shaft with a metal ferrule and a sliding ring to firmly lock in short pencil stubs. They don't cost much and let you get quite a lot of extra mileage from a pencil before it must be discarded. Typically, artists who work exclusively with colored pencils may have as many as a dozen or two of these extenders in constant use.

Some Small Empty Jars

Most colored pencil manufacturers provide very nice boxed sets designed so all the pencils stand up as if on display. Such boxes, however, can really accommodate only full-sized pencils comfortably. Also, artists who do a lot of colored pencil work tend to buy the pencils they need from open stock rather than as sets. A handy way of organizing assortments of colored pencils is in jars of various heights. The pencils can be grouped by color family, brand name, or any other way that makes them quick to locate.

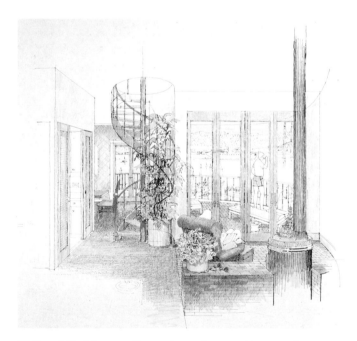

Willard K. Martin, View from Living Room, St. John's Development, Portland, Oregon, *1980. Colored pencil and ink, 14" × 15" (36 × 38 cm). Courtesy of the artist. When used in architectural design, color can make a persuasive difference in evoking a feeling of warmth and liveability.*

Fixative

There are times when a matte fixative can be used to advantage with colored pencils. It can also, however, alter the appearance in the red-violet end of the color spectrum, and for this reason it must be used sparingly. Different brands of fixative seem to have different effects on colored pencil hues. You can easily test your own brand of fixative for its particular color-altering effects. To do this, make generous-sized patches containing lines and tones of the colors to be tested on a small piece of your usual drawing paper. Fold the paper so that it masks off some of the color, then lightly spray the exposed color as you would a drawing. When the paper is un-folded, the colors of both areas should look about the same. If they do not, if the sprayed side is intensified or changed, the fixative is acting as a solvent.

A cautionary note about using fixatives: some brands now offer a "no odor" feature. If you use one of these, be aware that its toxicity will still be in the air, despite the absence of an odor to warn you.

A Drawing Board and a Light

Almost any smooth surface can serve as a drawing board, as long as its surface is larger than the drawing paper. Although a standard, adjustable drawing board is a desirable item of equipment, a simple portable board (either Masonite or basswood) provides the freedom to set up swiftly at almost any location. Care should be taken to protect your drawing board, because bumps and dents on the surface may distort drawing results.

The best kind of lighting is usually the common incandescent type, in combination with whatever ambient daylight is present. A valuable rule of thumb with artificial lighting is to use, whenever possible, the same kind of light under which the finished work will be viewed. Fluorescent lighting is risky, as it can change the appearance of colors.

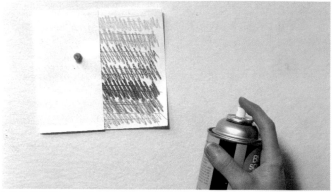

To test a brand of fixative for color-altering effects, make patches containing lines and tones of colors on a small piece of drawing paper. Fold the paper to mask off some of the color, then lightly spray the exposed part as you would a drawing.

Unfolding the paper quickly reveals which colors are most affected, and by how much. In this case, a great change can be seen in the purple, with lesser changes in the red and blue. The other colors were barely changed.

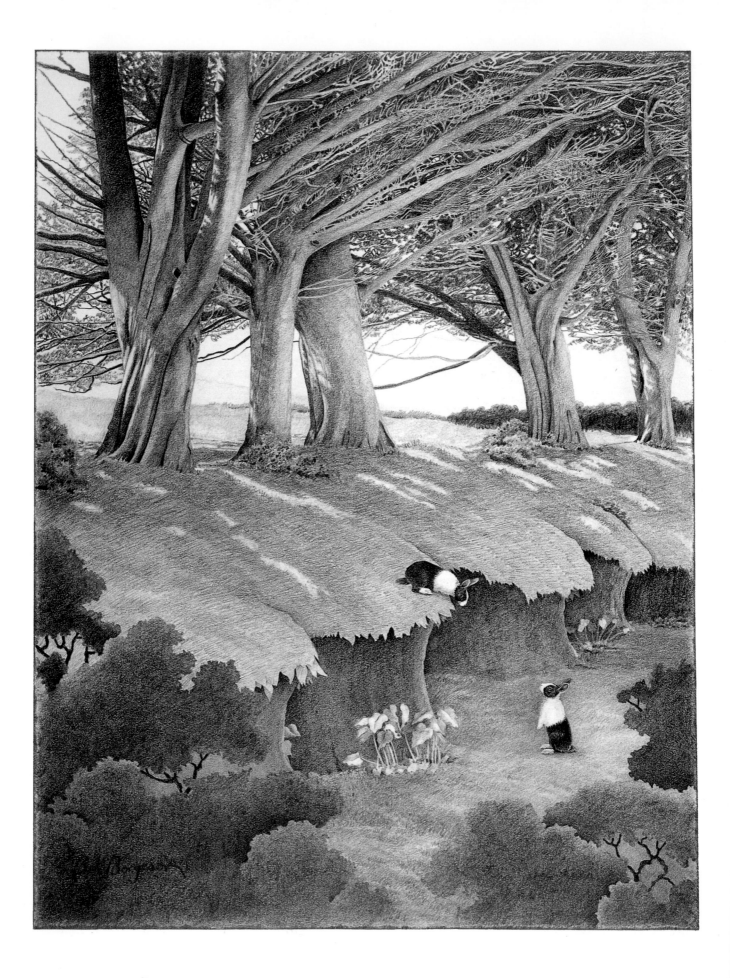

3 Characteristics and Handling

The tools of every medium have their own characteristics; it is these characteristics that ultimately determine how such tools can best be used. Viewed in this way, the most singular characteristic of a colored pencil is the fact that it is *not* a graphite pencil. Which is not quite the description-by-omission it seems. Because most of us have used graphite pencils all our lives, we are comfortable with them. And more often than not, the first use of a colored pencil seems by simple logic no more than a change to color.

Bet Borgeson, Rabbits and Blue Trees, 1989. Colored pencil, 19½" × 26" (49.5 × 66 cm). Private collection. All of the colors in this drawing were mixed by layering two or three pencil colors together. Note the granularity—the small flecks of white paper—in the closeup view above. This is a characteristic look of colored pencil applied with medium pressure on medium-grained paper.

But this logic is false. When colored pencil is used in the same way that a graphite pencil is used, the results often prove disappointing, and the truth quickly becomes apparent. Colored pencils are—despite all similarity of outward appearance—very different from graphite pencils.

For the successful handling of the colored pencil medium, keep in mind the following characteristics:

Colored Pencils Are "Transparent"

A major difference between colored and graphite pencils is that colored pencils are semiopaque, a quality that can loosely be called "transparent." In some ways, this makes handling them similar to handling watercolor, which is also based on a transparent system of pigmentation. Because of the transparent quality of colored pencils, the hue of one pencil applied over another will combine visually to create a new hue.

An example of this transparent quality can be seen when the hue of a yellow pencil overlaid on that of a blue becomes a green. Artists who regularly work in this medium handle colored pencils in this way, layering from two to as many as ten separate hues for composite results. Such complex color constructions are pleasing and involving to look at and can—sometimes with astonishing accuracy—resemble the mingling of color in nature itself.

Color right out of the tube—in the context of oil painting—is said to be raw and to lack

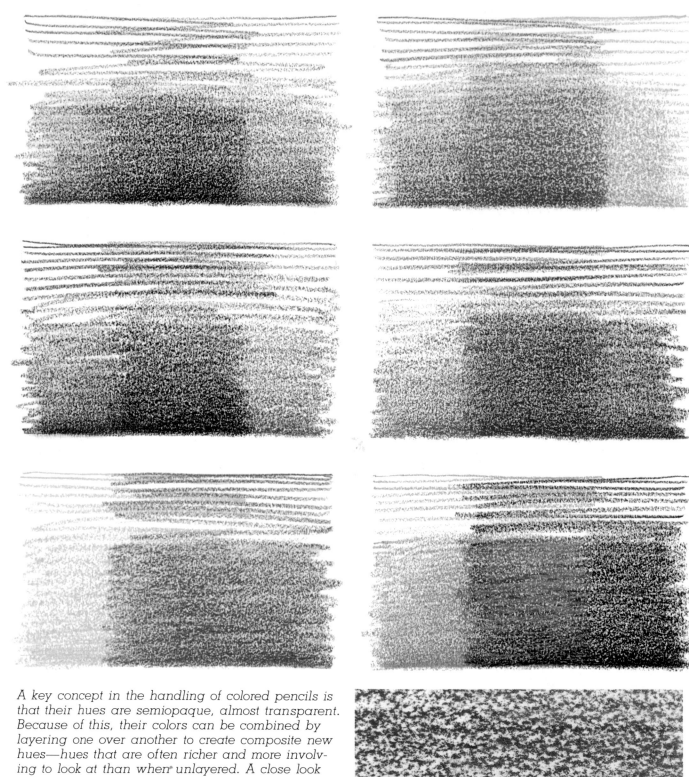

A key concept in the handling of colored pencils is that their hues are semiopaque, almost transparent. Because of this, their colors can be combined by layering one over another to create composite new hues—hues that are often richer and more involving to look at than when unlayered. A close look (right) at two layered colored pencil hues—a 924 crimson red and a 903 true blue—shows how the resulting combination continues to contain elements of the two separate hues as well as the newly formed hue.

subtlety. Similarly, this is true of colored pencils; unmixed hues almost always convey a simplistic rawness when compared with layered or constructed hues. The handling of colored pencil's transparency, which is its greatest difference from graphite, cannot be ignored if any effectiveness or breadth in this medium is to be realized.

Colored Pencils Contain Color

As obvious as the above statement may seem, there is a compelling reason for stressing it, because when color is inherent in any medium, the considerations of its application techniques begin to arise. Is the color applied thickly or in thin glazes? Is it to appear dense or sparse? In painting, the application of color is manifested as brushwork and the support surface. With colored pencil, the control of color application is handled with pencil pressure and paper texture.

Depending on the techniques used, colored pencil work can reflect the character of a drawing or it can look more like painting, and it can resemble either one without the use of solvent. In yet another difference from graphite—in which pencil pressure is varied to modify the width and value of line—degrees of pressure are used in colored pencil work to modify the texture of the paper itself. Colored pencil pressure also influences the intensity of hue: light pressure yields a sparseness of color; heavy pressure produces color density.

Pencil pressure is related to the degree of "tooth" on a paper's surface. Paper is composed of interwoven fibers that up close resemble a tiny maze of "hills" and "valleys." When a colored pencil travels lightly across a paper surface, the pigment material becomes deposited only on the hills. Flecks of unpigmented paper in the lower valley areas appear as an overall granular texture; this is the look associated with much of drawing.

By contrast, when colored pencil is applied to the same paper surface with heavier pressure, the pigment not only begins to build up on the hills, but also is pushed down into the paper's valleys. As flecks of clear paper in these valleys become less visible, the work takes on a less granular look. The fluid look of densely massed color closely resembles the look of color in painting.

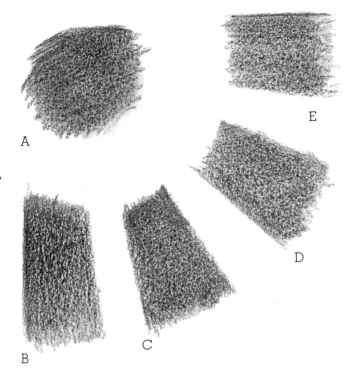

A

E

D

C

B

Constructing Hues

In this example, four hues (B through E) were constructed to approximate the single pencil hue of A. Because a printed reproduction is not quite the same as its source, you can best appreciate these effects of hue constructions by trying it with your own pencils.

Begin by making a patch of 937 Tuscan red as at A. Do this with medium pencil pressure. At B, lay down a patch of 932 violet, then overlay this with a 924 crimson red and a 916 canary yellow. If pencil pressure is kept consistent with all three of these pencils, the resulting, more complex hue should closely resemble the unmixed hue of A.

At C, combine a 932 violet with a 922 poppy red and a 916 canary yellow. At D, overlay a 943 burnt ochre with a 931 dark purple, and at E, a 947 burnt umber with a 924 crimson red.

Although all four of your constructed hues will resemble the single pencil hue at A, each will contain its own flavor. This intermingling of color, which adds complexity and subtlety, can make a hue more interesting. It can also offer flexibility, when needed, in the modulation of hue.

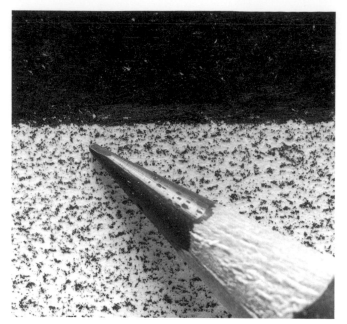

The effects of pencil pressure on a paper's surface can be seen in this closeup view. The dark area at top is dense pigment material deposited on the paper with heavy pressure. Few visible flecks of white remain of the paper's valleys. The granular area at bottom represents the same dark pigment material—applied with light pressure—deposited only on the paper's hills.

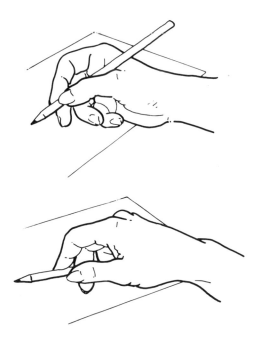

The two basic ways of holding a pencil are the upright grip (top), which can deliver precision, and the underhand grip (bottom), which can deliver a more gestural stroke. There are many personal variations on these, but how a colored pencil is held always has an effect on color application.

The way in which a pencil is held also affects the look of a drawing and relates to pencil pressure. There are two basic ways of holding a pencil: the upright grip—the way most of us first learned to use a pencil—utilizes the pencil tip. This grip allows optimum control of movement and pressure and is usually the route to precision.

The underhand grip—with the pencil held out from the hand by forefinger and thumb—makes use of either the pencil's tip or its shaft. This is the grip assumed almost automatically when drawing to large scale or when drawing while standing. Although this grip takes some practice for gaining control, it encourages use of the whole arm, not just of the wrist and hand, and is considered best for a spirited or gestural stroke.

However, you probably won't rely on either grip in its purest form. More likely, you will invent variations of both as needed, depending on such things as how your own hand is constructed—the spread of your palm, the length of your fingers—the top-to-bottom angle of your paper, and whether you are sitting or standing. It is not a question of what is correct. There is no correct or incorrect way of holding a colored pencil, beyond what works best for you. What is important is becoming aware that the way a pencil is held plays a part in handling color application.

Colored Pencils Are Forgiving

One of the extra benefits of working with colored pencils is that, like oil paints, they are forgiving in use. Whatever techniques of line or tone are attempted, there is plenty of room for error and recovery. As in painting, a color can be laid down, then adjusted and readjusted as a sought-after value or hue is gradually developed. It is not a "do-or-die" medium.

A Note on "Wax Bloom"

When heavy pressure techniques are used or when many layers of colored pencil are superimposed, a condition called "wax bloom" sometimes occurs within a week or two that looks like fogging or fading. This is caused by an exuding of excess wax on the paper's surface. And although it is not a serious condition, it may seem startling when seen for the first time.

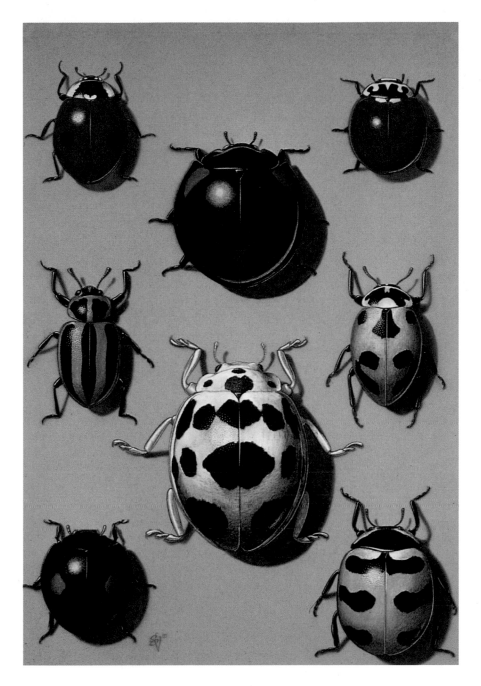

George L. Venable, Coccinellidae (Lady) Beetles, 1984. Colored pencil on Cronaflex UC-4, carbon dust on reverse side, 16″ × 20″ (40.6 × 50.8 cm). Courtesy of Dr. Robert D. Gordon/ USDA. This illustration by George L. Venable, a senior scientific illustrator at the Smithsonian Institution, was executed using very firm pencil pressure on a virtually grainless translucent drafting film. Vividness of color and a look of fluidity are characteristics of this technique. The overall visual effect in this drawing is more akin to painting than to the granularity often associated with color drawing.

Fortunately, wax bloom is easily corrected or avoided altogether. On a completed drawing, wax bloom can be removed from affected areas by lightly rubbing the surface with a soft cloth. Because colored pencils do not smudge easily, this rubbing should not disturb the drawing. As a follow-up, one or two light coats of fixative can then be applied, if you are sure that it will not alter the color.

To prevent wax bloom from occurring in the first place, a drawing can be sprayed immediately following its completion with a good quality fixative.

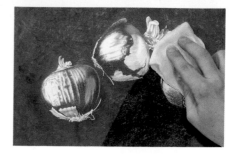

Layering Hues

In these patterns, the one at the top was drawn with three unmixed colors. The lower drawing was constructed by a layering of hues to achieve a similar color scheme. The difference between the drawings is subtle but important. There is opportunity in the layering method of the lower drawing, as there is not in the other, for the hue modulation needed to gain complexity and interest.

Effects of Pencil Pressure

Pencil pressure is the only difference in these two drawings. The same colors were used in both, but in the top drawing they were lightly applied, while in the lower drawing a heavy pencil pressure was used. This difference in color application can result in a look of drawing or painting.

Effects of Wax Bloom

The veiling effect of wax bloom, when it occurs, can be clearly seen at left in this closeup view (top). In the area at right, it has been wiped away.

(bottom) Wax bloom—the exuding of excess wax to a paper's surface—results from the use of heavy colored pencil pressure. It can easily be wiped away with a soft cloth. This can be followed by a light application of fixative to prevent its recurrence.

(right) Bet Borgeson, Formal Tulip Bouquet, 1991. Colored pencil on Rising museum board, 14″ × 18½″ (35.6 × 47 cm). Light pencil pressure need not necessarily mean a lightness of value. The green pencils used in the negative space are inherently dark, making it possible to achieve a satisfyingly dark value with only medium pressure and thus preserving the paper's tooth for a granular look.

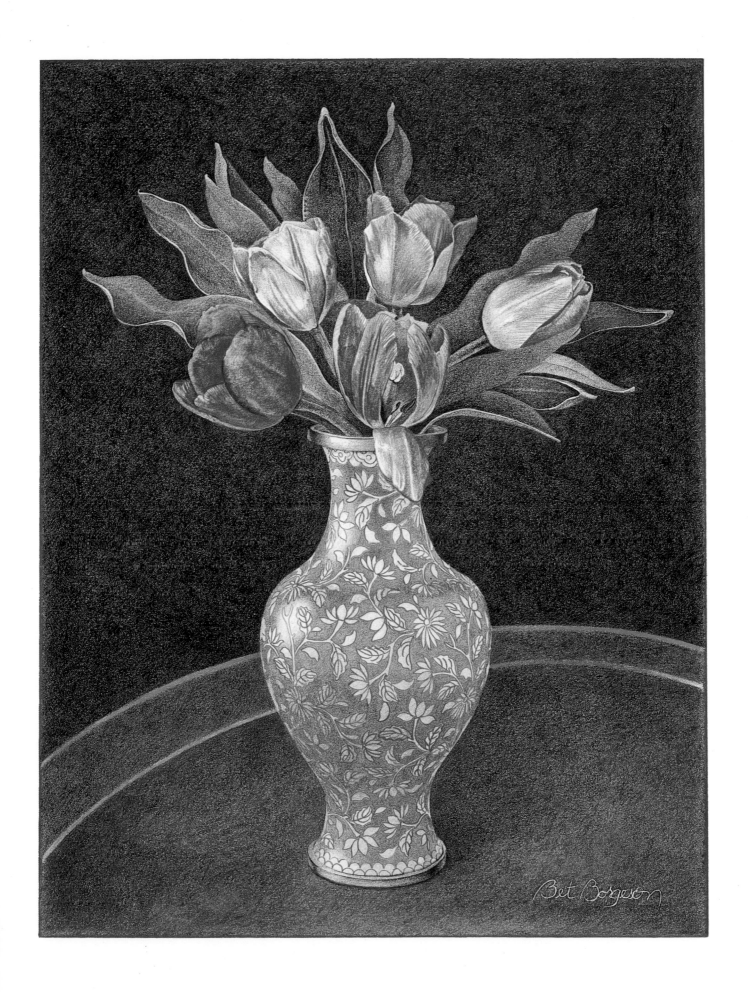

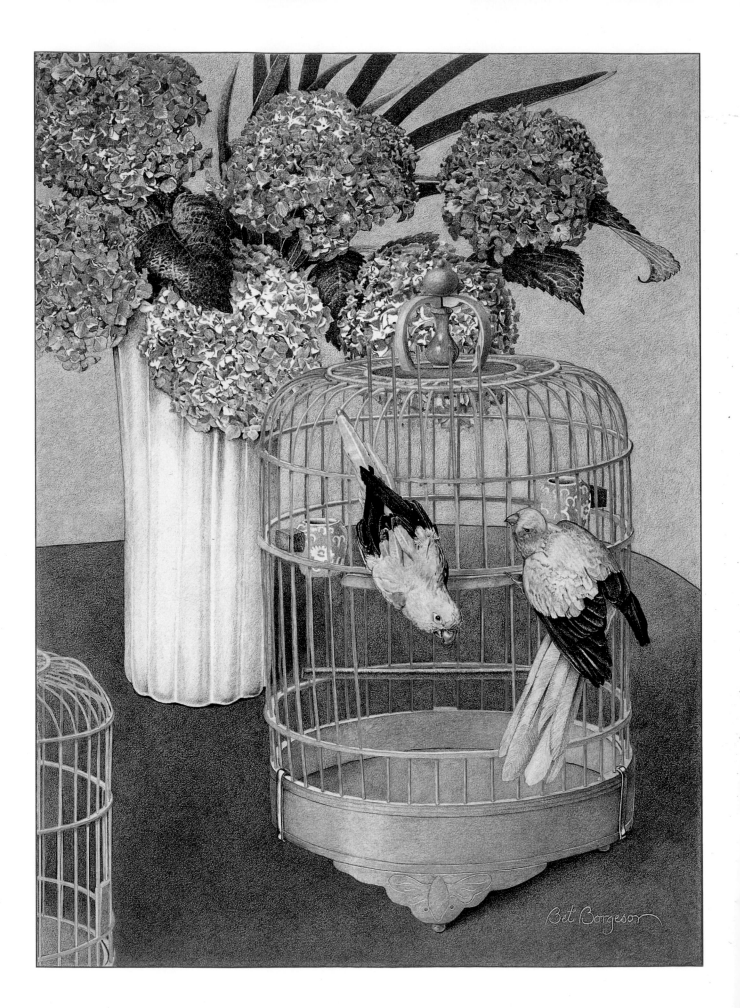

4
Mixing Color

The process of color mixing is exciting in any medium, but there is a special thrill in the handling of color with colored pencils. This may be because the colors they yield are so instantly available—with no setting up of cumbersome paraphernalia—and can be so rapidly mixed and changed on the paper.

This quality of quick results has a positive effect on those who work with colored pencils. Artists who work with them often report experiencing an intensity of concentration—a total absorption—which takes them by surprise. The speed and directness of handling, combined with the medium's intimate nature, serves as a spur to further experimentation, as a quietly active pursuit of color brings fresh and unfamiliar results.

If you have not yet started a personal workbook for your own colored pencil drawings, this would be a good time to think about doing so. When you begin to experiment with colored pencils, the most useful kind is one with pages of a medium-grained surface very similar to that of your every-day drawing paper. For example, the previously recommended Strathmore 400 Series drawing paper is inexpensively available and comes in a 5½" × 8½" notebook, and also in small spiral-bound tablets. Either version would make a good workbook.

Bet Borgeson, Companions, 1991. Colored pencil, 17½" × 24" (44.5 × 61 cm). Courtesy of the artist.

The Dimensions of Color

Color mixing involves the three dimensions possessed by every color: hue, value, and intensity. The varying of a color—what color mixing is all about—is a varying of one or more of these dimensions. Before we go on, let's briefly discuss the meanings of the three dimensions of color.

Hue. This is a color's name: red, yellow, blue-green, etc. It also denotes the place of a color on the spectrum. Hues are said to have "temperature"—those approaching red are warm and aggressive, those nearer blue are cool and reticent. To visualize other relationships among hues—to show which are complementary (opposite), for example, and which are adjacent (neighboring)—colors are often arranged in their spectrum order on a color wheel. Black, white, and the various grays are not considered hues, but neutrals.

Value. This refers to the lightness and darkness of a hue, as if on a scale from white to black. Gradations of value are critical when describing form in art, building a composition, and evoking mood.

Scales of value, often presented in chart form, can contain from a few to several distinct gradations. Assessing value is easily done with grays or with a single hue. It becomes more difficult when several different hues are involved as a group, but this becomes easier with practice.

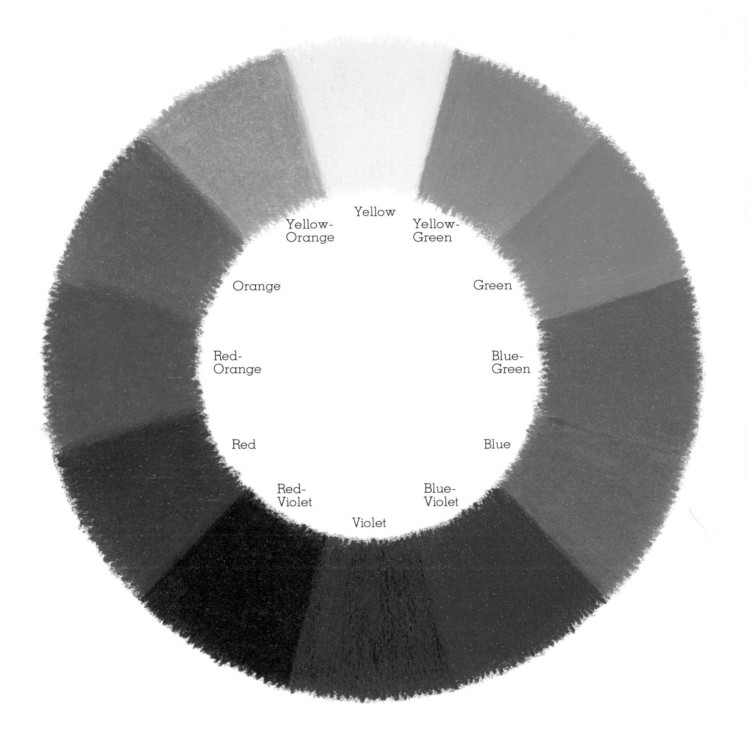

Yellow

Yellow-Orange　　　Yellow-Green

Orange　　　　　　　　Green

Red-Orange　　　　　　Blue-Green

Red　　　　　　　　　　Blue

Red-Violet　　　　　Blue-Violet

Violet

The arranging of hues on a color wheel is a theoretical concept; it relates the hues to one another as they occur in the natural spectrum. Those adjoining each other are said to be adjacent, and those opposite are complementary. Although the makers of most brands of colored pencils offer all the hues found on such a wheel, these hues may vary somewhat from brand to brand. Also, a hue that is otherwise accurate may appear too light or too dark in value or be lacking in intensity. Some of these effects can be seen in this color wheel constructed with colored pencils.

Intensity (also called saturation). This describes the purity of a color in terms of its vividness or dullness. A hue of strong or high intensity appears vivid and saturated. It also has a simple and straightforward quality and is usually an unmixed hue. A hue of weak or low intensity appears dull and unaggressive. What must be remembered here, however, is that in a color sense, "dull" is not a pejorative. It is merely the opposite of "vivid."

Altering Color's Dimensions

Color mixing is done by deliberately altering one or more of color's three dimensions. These color alterations are managed in a variety of ways—many of them unique to the colored pencil medium.

The *hue* of a color is changed by mixing another hue with it. This is done in two basic ways:

1. *Two or more pencil hues are combined by superimposing or layering one color on top of another.*

2. *Two or more pencil hues are combined by placing them side by side.*

The *value* of one color is changed by adding another color or a neutral that is lighter or darker to the first. There are three basic methods for accomplishing this with colored pencils:

1. *Change in pencil pressure.* When you look at a colored pencil lead, you are seeing that pencil's color at its darkest value. By changing pencil pressure, you are in effect combining more or less of the paper's whiteness with the pencil's color. Moderate to heavy pressure will transfer a deeper value to the paper; lighter values will be expressed by lightening the pencil pressure.

2. *Overlaying a color with a white or black pencil.* A white pencil overlaid on a dark color will raise or lighten that color's value, but overlaying has little effect on colors that are already of a medium to light value. White pencil excels as an overlay when rendering the effects of glazed surfaces, such as those found on porcelain or stoneware.

Black pencil overlaid on a color of any value will lower or darken that color's value. Because black also deadens hue and affects the intensity of a color, overlaying black pigment is a way of changing value that must be used very carefully.

3. *Overlaying a pencil's color with a lighter or darker color.* Although this method also changes a color's original hue and intensity, it is the colored pencil medium's liveliest way of changing values. The new values arrived at seem crisp and decisive and filled with a richness of hue.

The *intensity* of a color can also be altered in many ways. Because many colored pencils are vivid in color, the goal is often to reduce or modulate an intensity. The following four methods will *decrease* a colored pencil's intensity:

1. *Overlaying a pencil's color with a neutral gray pencil.* This method does not change the original color's hue and only slightly changes its value. It does, however, produce a feeling of color loss.

2. *Overlaying a pencil's color with black pencil.* This method is used to decrease the intensity of dark colors, but it does not work well with light colors because of black's obvious contrast of value with them. And when the intensity of any color is decreased by overlaying with a neutral gray or black, the resultant mixture is likely to appear gloomy in comparison with other hues. But this, like all color mixing, becomes a question of appropriateness; a look of blackened color, selectively used, can sometimes be a good contrasting foil to further strengthen an area of brilliant intensity.

3. *Overlaying a pencil's color with a complementary pencil hue.* If the second pencil's hue is *exactly* complementary to the first, a light overlaying will reduce the first color's intensity but will not change its hue. If the second hue is not exactly complementary, which is the usual case, overlaying will cause the first hue to change slightly. But with either outcome, the use of two colors, rather than a color and a neutral, usually makes this a more satisfactory way of reducing intensity. Color modified in this way is almost always more pleasing to look at than colors modified with neutrals.

4. *Thoroughly combining a pencil's color with the two colors adjoining it on the color wheel.* For example, to use this method for lowering the intensity of a yellow-orange pencil, you would overlay with an orange and a yellow—the colors that are adjacent to yellow-orange on the color wheel. The result becomes a beautifully subdued yellow-orange, with no change in hue and only a slight change in value. The advantage in appearance here comes from using color to lower intensity rather than using a neutral.

When the aim is to *increase* rather than decrease a color's intensity, colored pencils are used in the following four ways:

1. *Loosely combining a pencil's color with the two colors adjoining it on the color wheel.*

When similar pencil colors are loosely combined or mingled, the effect is one of added richness and depth, which usually appears to brighten the original hue's intensity.

2. *An increase in pencil pressure.* As shown in the preceding chapter, heavy pencil pressure will produce a denseness of color because the pigmented material is forced down into the valleys as well as onto the hills of a paper's tooth. Although a color's hue is not changed by this method, its value is darkened dramatically. This way of using colored pencil also produces an opaqueness that looks like painting.

3. *Overlaying a pencil's color with a white pencil.* When a white pencil is firmly applied over a colored pencil's hue, the original hue

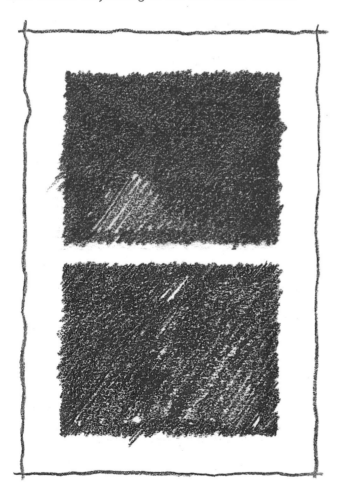

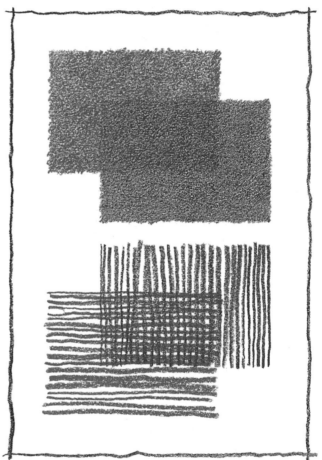

Both these colors are of the same hue family, but the top color is vivid, or high intensity, while the lower color is dull. "Dull" in this context is not a pejorative term; it merely means the opposite of "vivid," and can often serve as a useful variation.

Colored pencil offers two basic methods of altering a color's hue: by tonally overlaying or superimposing separate hues to construct a new hue (top); and by the juxtaposition of separate hues (in this example with a linear technique) for the visual illusion of a new hue (bottom).

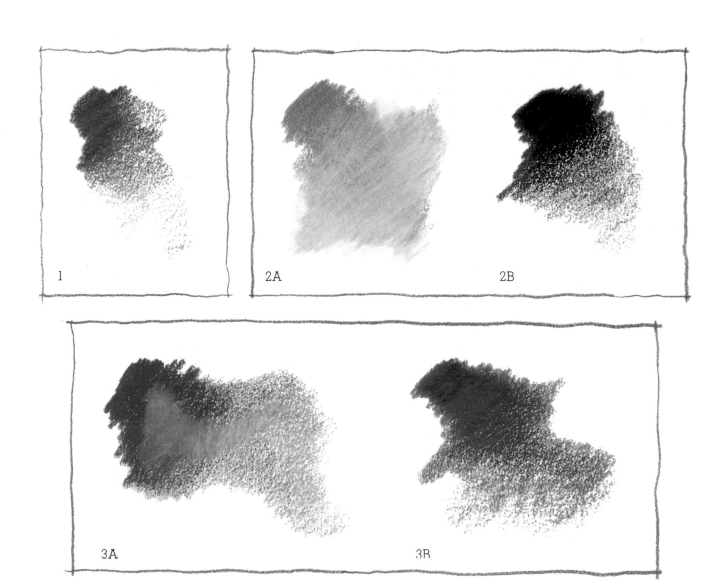

1

2A 2B

3A 3B

appears glazed, and its value lightened. But when the pencil's original hue is then applied over this mixture, the hue becomes intensified, and its original value is restored. For example, to increase the brilliance of a Prismacolor 903 true blue, a 938 white pencil is applied firmly over it. The resultant blue will now be higher in value. But when a subsequent layer of 903 true blue is firmly applied over the true blue and white, the true blue's value is restored and its color will be more intense.

4. *Combining a pencil's color with solvent.* Water, turpentine, markers, even aerosol fixatives, can operate as solvents for colored pencils. The intensity of a colored pencil's color is increased more by a solvent than by any other means. Sometimes, however, the use of a solvent brings with it a slight change in hue.

Changing Value

There are three basic ways of changing the value of a colored pencil's color:

1. Changes in pencil pressure. As more or less whiteness of paper is allowed to show through, the value of a color will appear darker or lighter.

2A. Overlaying a medium-to-dark color with a white pencil. This lightens value.

2B. Overlaying any color with black will darken its value.

3 A & B. Overlaying a color with another color, lighter or darker than itself. This method also causes changes in hue and intensity.

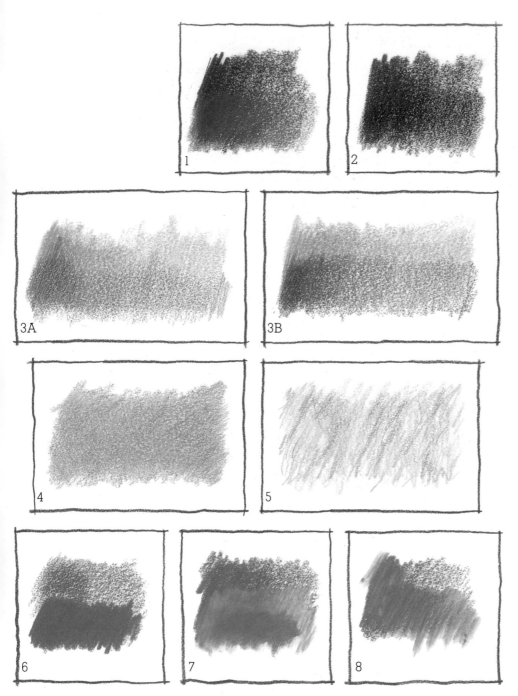

Changing Intensity

A colored pencil's color can be lowered or raised in intensity by various methods.

Intensity is decreased by:

1. Overlaying the color with a neutral gray.

2. Overlaying the color with black.

3A. Overlaying the color with a complementary hue. A second color exactly complementary to the original should yield little or no hue change.

3B. Using a near-complementary over the original hue.

4. Thoroughly combining a pencil's color with the two colors adjoining it on the color spectrum. This method tends to subdue intensity more than actually reduce it. In this example, 917 sunburst yellow was subdued by mixing 918 orange and 916 canary yellow with it.

Intensity is increased by:

5. Loosely combining a color with the two colors adjoining it on the spectrum. This is more an optical than a physical effect, related to how we perceive juxtaposed colors. This time, the 917 sunburst yellow is made more intense with the same 918 orange and 916 canary yellow that were previously used to reduce its intensity.

6. Increasing pencil pressure. Raising intensity in this way also greatly darkens a color's value.

7. Overlaying a color with white pencil, then adding more original color to this mixture.

8. Combining a pencil's color with solvent. The result visually resembles that of heavy pencil pressure. However, use of a solvent can also intensify color of light value without darkening it.

Developing a Discerning Eye

A good eye for color is worth striving for. Sometimes this ability seems intuitive, but in more cases than not, it has been patiently learned. Two areas of skill are involved in developing a good eye for color. One is an ability to recognize and describe a color, whatever its surroundings, in terms of its three dimensions. With this ability, rapid judgments can be made about an existing color mixture's relevance or usefulness. The second area of skill, which grows out of the first, is an equally sure knowledge of how to alter color appropriately by making changes in its dimensions.

If you'd like to sharpen your own eye for color, try looking closely and as objectively as possible at colors around you, identifying them by each of their dimensions. Try imagining changes, one at a time, in these dimensions. In your own workbook, try altering small patches of color by manipulating the dimensions of that color, by changing the hue, the intensity, or the value. Then compare the altered colors with the original color. Continue these efforts in your drawings.

As you mix the colors you need for your drawings, you will soon discover that seeing color accurately is not as simple a thing as you might have expected. This is because a single color's look can be dramatically affected by so many factors, such as lighting, the texture of a drawing surface, personal preconceptions, and by the other colors that adjoin or surround it. For example, a color looks more intense when seen alone than it does when seen on or near a color of the same hue but of less intensity. A color of medium value looks like a lighter value when it is placed against a dark background, but it appears to have a darker value when the background or nearby color is lighter than itself.

A color's temperature is also a factor in seeing color. Warm colors appear warmer and cool colors appear cooler when they are seen against their opposites in temperature. Color temperature also plays a strong part in color's seeming ability to advance or recede in space; warm colors often appear to come forward, and cool colors appear to retreat. A color of more brilliant intensity or of lighter value than its neighbors also seems to come forward in space.

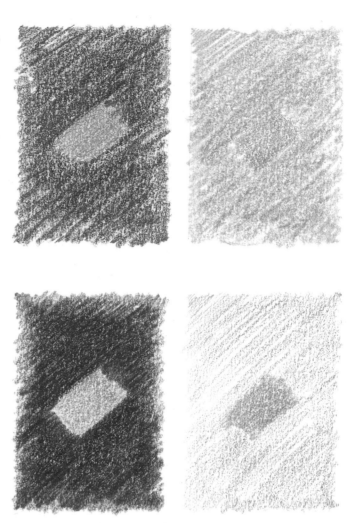

Our perception of color is influenced by many things. The small patch of 918 orange in the top pair looks more yellow when surrounded by red, and more red when surrounded by green. In the bottom pair, a single value of 918 orange looks lighter against a 901 indigo blue of dark value, and darker against the same blue of light value.

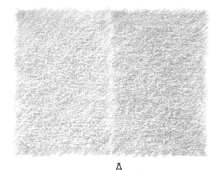

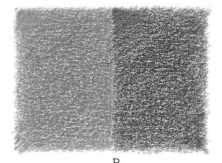

A

B

C

A truism of color perception that is not always true is that warm colors invariably advance and cool colors recede. With no other visual cues than the colors themselves, the second two of these three combinations can be seen to advance or recede for different reasons. In A, the warm orange appears to come forward from the cooler blue at its side. But in B, the cool blue also comes forward because it is brighter in intensity than the warm but dulled red. And in C, a light value of blue seems to advance from a darker value of the same hue.

Color also has a profound effect on our emotions and on how we perceive space. To better understand how this pertains to drawing with colored pencils, let's consider what color can offer a drawing's mood and structure:

Mood

While we don't completely understand how sensations of color affect us emotionally, it is pretty apparent to all of us that they do. We are drawn to color, and we react to it. Our memories and our associations with the colors of life around us bear this out. We all have special feelings for special hues.

For many of us, warm hues suggest activity and vitality. Red, among these hues, may seem particularly compelling. But in great quantity, this same red may bring a shift in mood from vitality to something nearer paralysis. Our moods can also be swayed by a color's value or intensity. Light values may seem to us cheery and open, dark values gloomy. High intensity of color may seem to promote excitement, but low intensity brings a feeling of calm.

A good beginning toward evoking mood in your drawings can be made by observing the colors in your life. Try asking yourself, in environments that set a mood, what part color plays in this setting. Look for the dominant color, defining it by its value and intensity as well as by its hue. Look for contrasts among these things. Note how the location and amount of color can affect mood.

As a practical experiment, make a few small thumbnail drawings with your colored pencils. Use as few drawn clues as possible to suggest mood, except those of color—its placement and its quantity.

Structure

Color also can work its effects on a drawing's structure, which refers to all the elements in a drawing that contribute to the illusions of form and space. You will find as you work with colored pencils that color alone can build some of structure's illusions. It was, incidentally, to working with this premise that the colorist Paul Cézanne devoted much of his painting life.

The capacities of color alone to achieve effects of distance, perspective, solidity, and changes in plane hinge largely on its ability to visually advance or recede. In practical terms, this "action" of color can be utilized when a shape—a table, for instance, or an object on the table—needs to be brought forward or pushed deeper into a picture's space.

A color's hue—aside from its relative warmth or coolness—can also be used to enhance the modeling of form. Because colors under different degrees of light appear to shift toward adjacent hues, an increase in illumination makes blue, for example, become more blue-green. Red, under this condition, becomes nearer red-orange. With decreasing illumination, blue becomes more blue-violet, and red more red-violet.

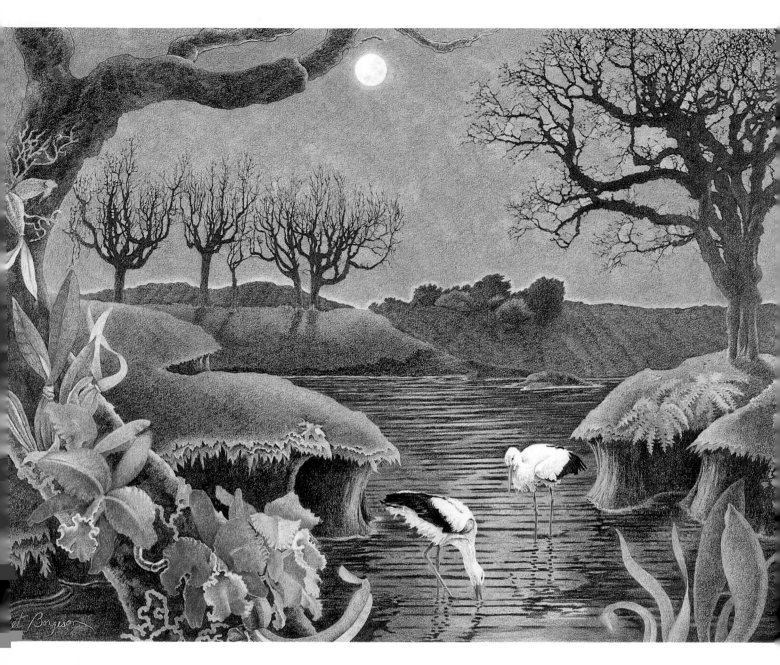

Finally, perhaps the single most important thing to know—for gaining adeptness at mixing colors as well as for sharpening an eye for color—is that all colors have equal status in art. None is by definition useless or ugly. Each, given proper circumstances, can be beautiful and hard-working. What is really being sought after, when colors are mixed, is appropriateness. The great advantage of colored pencils, as a medium for learning about as well as for drawing with color, is the speed and ease with which you can put color ideas to practical tests.

Bet Borgeson, Tender Light, *1989. Colored pencil on Rising museum board, 25½" × 19½" (64.8 × 49.5). Private collection. Color has psychological implications for us all, and these can mightily affect the mood of a drawing. For this reason it is always important that color reinforce an intended mood, not work against it.*

In this drawing, the somber mood begun by the stark and minimal bare-tree landscape is supported by the blue hue that seems to influence almost all the other color mixes. The slowness of value changes also seems to contribute a quietness to the scene. Even the red-orange orchids, ordinarily viewed as a passionate note, in this austere setting seem to convey a brooding quality.

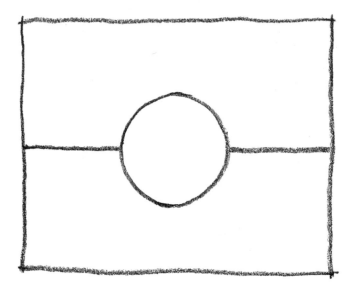

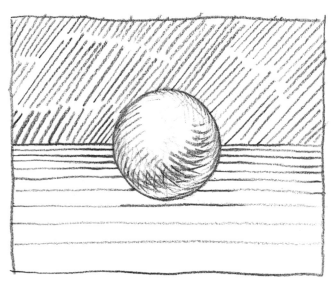

Creating Structure with Color

Try this simple experiment, which contains a key to how color can be used in creating a drawing's structure.

With a black pencil, draw the schematic shown of a circle within a rectangle, and the rectangle divided lengthwise by a line. The elements of this little drawing appear flat, with no feeling of dimensionality. Still using a black pencil, add an illusion of form and space by diagonally hatching the area above the bisecting "horizon" line, and by adding some light horizontal strokes to symbolize a lighter foreground. Add some additional hatching lines as a core shadow to the circle, making it seem a sphere. With these changes in value you have constructed a linear drawing that contains a credible illusion of form and space.

Adding a few appealing colors to this drawing might now seem the logical way to convert to color—and is often the kind of approach made to color drawing. However, the only truly satisfactory way to accomplish structure in drawing with color is to begin with color. To see how color creates form by itself, outline the rectangle of the schematic with a 922 poppy red pencil (or combined with a 901 indigo blue). Draw a circle with a 903 true blue and the bisecting line with a 922 poppy red. These colors—chosen for their particular abilities to advance and recede—will serve as the basis for creating form and structure.

Because the background above the horizon is meant to recede, a 901 indigo blue (a cool hue of low intensity) is a good choice for the diagonal hatching in this area. To bring the foreground forward, begin with a 922 poppy red near the horizon, warming it with 918 orange as it comes forward, and ending with a 916 canary yellow where it is to read as farthest forward.

Because color also has the ability to suggest form by its shifts in hue under different degrees of illumination, our sphere, which is blue, ought to appear more green where it is most illuminated, and nearer violet where it is least illuminated. To utilize this aspect of color, draw the sphere's core shadow this time with a 903 true blue crosshatched with its adjacent hue of 932 violet. Further restate the bottom of the sphere with a 932 violet, and the top contour—where most light hits it—with the blue's other adjacent, a 910 true green.

You now have a second drawing that contains an illusion of form and space. But note how this second structural illusion, built with a combination of line and color, seems to more clearly state its feeling of form and depth, and also to evoke its own mood.

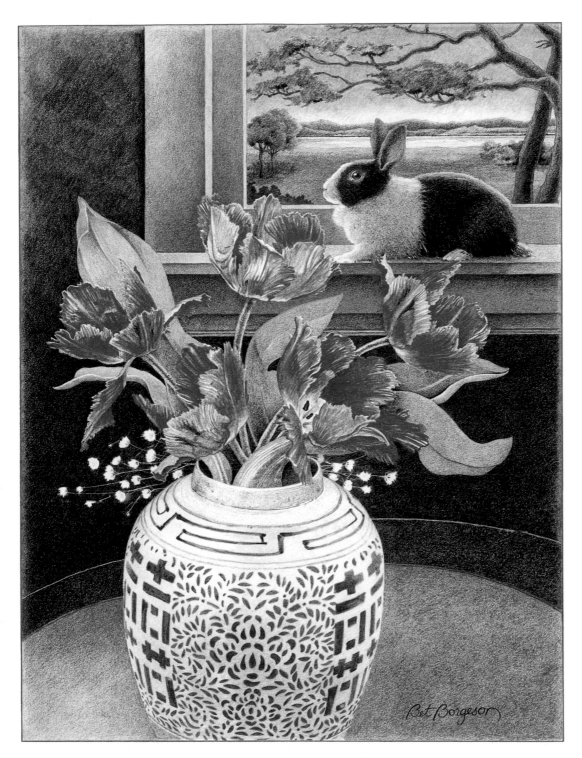

Bet Borgeson, Window Rabbit, 1990. Colored pencil on Rising museum board, 14″ × 18½″ (35.6 × 47 cm). Private collection. Although color is often regarded as a mere ornament of art, it can also be a hard-working component in the creation of spatial structure. In this drawing, a sense of space is first initiated by that most primitive tool of perspective, overlapping elements. But to positively reinforce this effect, advancing/receding color choices were made to emphasize foreground, middle ground, and distance. The pattern of the vase and the vivid warm red of the tulips help anchor these elements in the foreground. The colors begin to cool as they describe features beyond the bouquet. And, finally, the lightened color values of the landscape help to provide needed clues for distance.

Colored Pencil Techniques

and Demonstrations

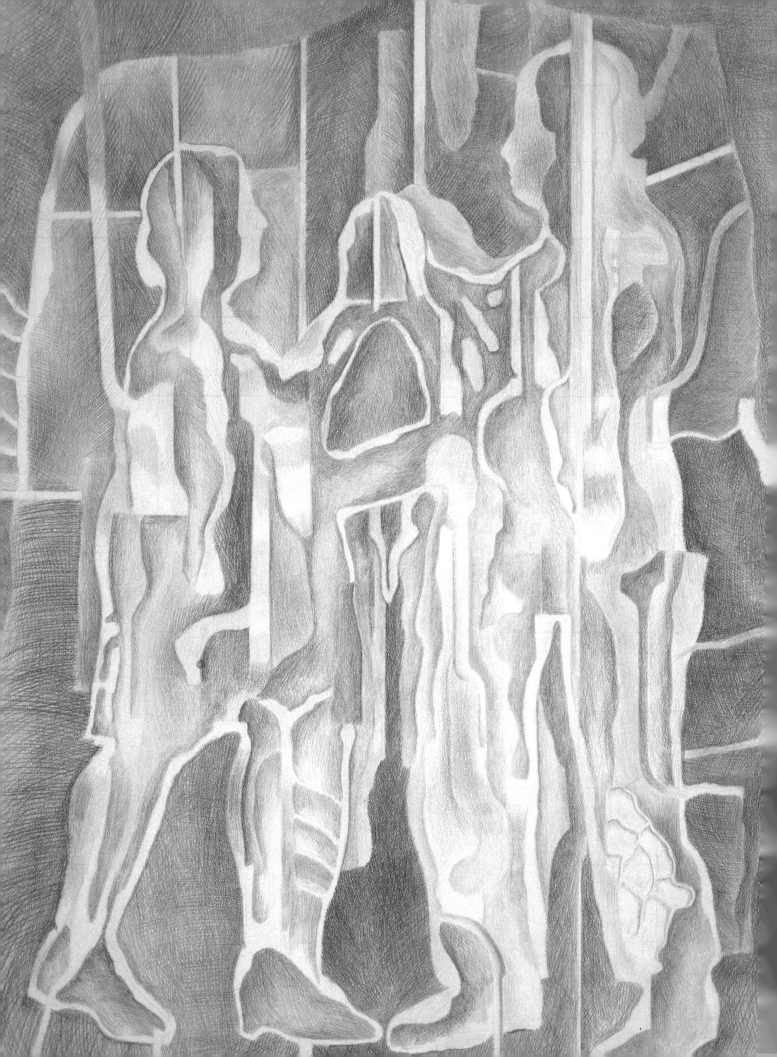

5
Linear Techniques

Drawing with line is fundamental to art. Line can be expressive, lyrical, tentative; it can be a beginner's first searching attempt or an experienced artist's final mark of authority.

In linear drawing—with colored pencils or any other drawing medium—the kinds of line that can be used are almost limitless. Yet all the lines of drawing generally fall into six types: four that are used to delineate edges or contours of form, and two that are used for value changes that suggest dimensionality.

The following are the four categories of line that are used for contour drawing:

1. *Wire line*—a clean line of unvarying width, often associated with contour drawing.

2. *Calligraphic line*—characterized by variations in width. The variations in this line are dependent on the artist's response to such factors as overlapping forms, weight, shadow, change in direction, or emphasis of a detail. This line can be a gestural stroke.

3. *Broken line*—a line that is not continuous but is sometimes repeated or overlapped. It is often used as a sensitive, searching line.

4. *Repeated line*—loosely parallel lines used to build up contours.

Although all of these contour lines can also be used to evoke dimensionality—which is the sense of form and space in a drawing that is conveyed by subtle changes in value—there are two kinds of line that are almost exclusively used for expressing changes in value:

1. *Hatching and crosshatching*—a series of parallel and crisscrossed strokes, which vary from carefully spaced to loosely organized.

2. *Stippling*—a placement of marks or dots that by both position and spacing can denote the value changes of modeling.

(opposite page) James S. Hibbard, Dancing Couple, *1981. Colored pencil, 21" × 28" (53 × 71 cm). Courtesy of the artist. In this linear colored pencil drawing, many kinds of hatching and crosshatching have been employed to build up color and to suggest tonality.*

A closer view of how colored lines have been overlaid with one another can be seen in the detail above.

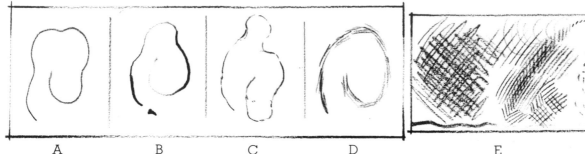

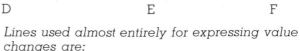

A B C D E F

Most of the lines used for describing edges or contours in linear drawing are derived from four basic kinds. These are:

 A. Wire line—a line of unvarying width

 B. Calligraphic line—a more gestural stroke of varying width

 C. Broken line—a searching or refining line

 D. Repeated line—a series of flowing, loosely parallel lines

Lines used almost entirely for expressing value changes are:

 E. Hatching and crosshatching lines—drawn loosely as at left, or more precisely as at right

 F. Stippling lines—marks or dots spaced densely or openly

Some of the effects pencil point has on line are shown below the hatching and stippling.

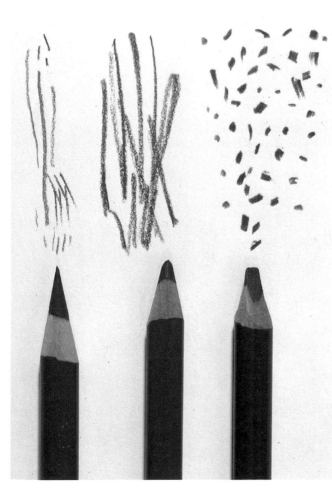

Although a sharp point (left) is used for much colored pencil work, a dulled point (center) is particularly useful for bold linear work. A chisel point for stippling (right) helps to avoid a look of too much uniformity.

These basic lines of linear drawing are all hardworking and useful, and for drawing where color is not a factor, the effects expressed by line almost always depend on modulation of value. *Drawing with color differs from this.*

The Colored Line

When a line is drawn with a colored pencil, all three of color's dimensions—hue, value, and intensity—become available. This property of colored pencil is important because it is what lies at the heart of drawing with color. This means that in addition to the alterations of value that are used to express form and space in drawing, there are also opportunities for expressing dimensionality with hue and intensity. And to truly utilize color's total capacity, it is essential that color and line not be regarded as two separate functions. To become the mutually supportive tools they can be, line and color must work together.

Lastly, if there is one essential idea to keep in mind about linear drawing with colored pencils, it is this: drawing with color is more than merely adding color to a drawing. To relegate the use of color to the lowly rank of embellishment can only minimize a drawing's strength. To use color fully, the artist must base a drawing's structure on it and must use line as a vehicle for color. This is how you will bring vitality to your colored pencil drawing.

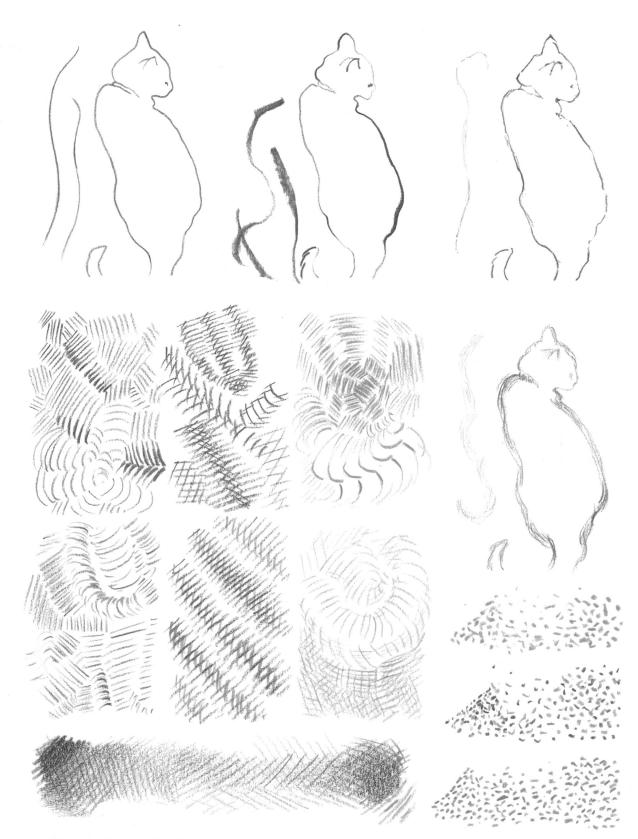

Practice Using Color with Line

In your own workbook try using color with the kinds of lines discussed earlier. Draw some simple contours, such as those suggested at top, using various color combinations. As you experiment with complementary and with adjacent or analogous hues,

note how these juxtaposed lines appear to create new hues. Try some hatching, crosshatching, and stippling similar to the examples shown, again using single hues and combinations of hues. You may notice as you do this that you are beginning to think of color before you think of line.

Demonstration:
Still Life with Linear Technique

Let's look now at how some of the ideas we have been discussing can be applied to an actual drawing. Our aim is to use color and line in an equal partnership. For a subject we can enlarge on our previous experiment with the rectangle and sphere. But instead of a simple sphere, let's use apples.

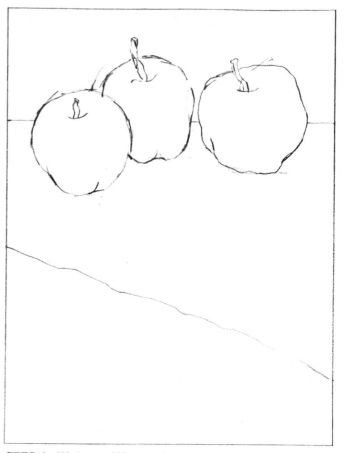

STEP 1. *In planning any color drawing, it is a good idea to start with a few quick thumbnail roughs, made with a graphite pencil, for working out a composition and an approximate value range. After this is done, the process of thinking about color can begin with colored pencils and bits of tracing paper positioned over the most promising composition. Various colors are then applied to see how they relate to each other. After a few tries with our colors and thumbnail compositions, we find that what promises to work well for this drawing is a basic triadic hue scheme of yellow-green, red-orange, and blue-violet. It is a lively scheme of primary and secondary hues and already begins to suggest additional hues that will help create our drawing's structure.*

STEP 2. *With an HB graphite pencil on a medium-grained paper, a large rectangle is drawn as a frame of reference, and our composition is very lightly blocked out within it. Graphite is used for this because it erases easily (as colored pencils do not), and these guidelines will soon be removed. This first blocking out of our composition (shown heavier here than it ought to be, for photographic purposes) is kept as free as possible from detail.*

STEP 3. Some of the elements—apples, tabletop, and the patterned fabric in the foreground—are now lightly drawn in. Although the apples are of a single variety, they must also be shown as individuals. A beginning toward individualizing each apple is made by lightly hatching the left one's contours with a 913 spring green. The middle one, which is a little farther back, is drawn with a darker and less intense 912 apple green, and the right one barely suggested for now with a 903 true blue, which will serve as a dimly lit version of a green. A 931 dark purple is used for the apples' stems, except for the middle apple's, which is drawn with a 901 indigo blue.

The surface of the tabletop is begun by laying in some short, horizontal hatching with a 901 indigo blue. These lines are vigorous but not dark; the idea here is to preserve what we can of the paper's whiteness. The fabric is conceived as patterned to complement the somewhat brusque linear feeling of the rest of this drawing. Because trying to exactly reproduce a complex pattern can be frustrating, and can also inject an unwanted hard-edged feeling, the repeated motifs are just suggested with a 924 crimson red and a 918 orange.

STEP 4. To achieve more depth and dimensionality, additional hue and line work are now integrated into the drawing. The background, which is to remain light in value, is stippled with a chisel-pointed 1063 cool grey 50%. This cool neutral recedes well. Subdued hue is added by also stippling the area with 903 true blue and 929 pink. Variations in the stippling marks, made by simply shifting the angle of a pencil's chisel point, add vitality to this kind of bold line work.

Modeling of the apple at left is continued with 913 spring green; a 917 sunburst yellow and a 924 crimson red are used to bring the apple's front part forward. This modeling of forms with hatching and crosshatching is done as if tactilely feeling the round contours of the apples.

More 912 apple green is used to model the contour of the middle apple; and to suggest a shadow cast by the left apple, a 907 peacock green is loosely drawn to break through the boundary between these two apples. This same color is used to restate the middle apple's right outside contour. For the apple at right, 913 spring green and 903 true blue are used to further model its form; and 932 violet is added to the area toward the back that seems to recede.

For the tabletop, 943 burnt ochre is used to suggest a wooden surface, and also to help bring this surface forward. To create some feeling of depth, a 931 dark purple is firmly applied to selected areas of the tabletop.

Evaluation: There comes a point in every drawing—when it is nearly finished—that we must pause and try to see it again with fresh eyes. This is a time for finding out what is necessary to complete the drawing and for attempting to accurately assess what problems remain. Although it is difficult to be coldly objective after this much investment of time and energy, it is the best hope we have for completing a drawing in anywhere near the way in which we first conceived it.

First, we must ask ourselves whether or not the values and colors are really working as intended. In our drawing, the background seems too light. It must be darkened. Also, the apples and the fabric need more development. A good question to ask ourselves now is whether the drawing as a whole contains what we might call a "worry spot." There is often a single area in a drawing that we suspect to be wrong from the beginning—maybe as early as our thumbnail color studies—but that we hope will somehow take care of itself. In most cases, unfortunately, this trouble spot does not get better, it gets worse.

Here, the worry spot is our leading players, the apples themselves. They are clearly having a problem holding their own against the contrast of the bold tabletop and the foreground pattern. They are almost lost.

This is the kind of worry spot that relates to the three dimensions of color. The hue of the apples seems all right, although perhaps a little too similar. But their value range definitely needs more punch—more contrast. The darks do not seem dark enough. The apples also recede too much because they lack intensity. More brightness in them, applied with vigor, might help them compete with the other elements.

Therefore, our evaluation reveals that there are some problems, some possible solutions, and some tasks to be done:
1. The background needs darkening.
2. The overall values need adjustment. More lights and darks are needed to develop the foreground and middleground.
3. The apples are in trouble. They must be darkened and brightened. This correction will also make their hues more complex.
4. A general crisping up of edges where needed—a customary final step—will probably help the tabletop extend better under the fabric and apples.

Green Apples, 1982. Colored pencil, 6⅝″ × 8¾″ (16.8 × 22 cm). Courtesy of Bet Borgeson. To finish this drawing—with our evaluation in mind—more 929 pink, 903 true blue, and 1063 cool grey 50% are stippled into the background. Boldness is added to the apples with additional loose and vigorous linear drawing. For the apple at left, the pencils used are 913 spring green, 931 dark purple, 924 crimson red, and 917 sunburst yellow. More 912 apple green and 907 peacock green are applied to the middle apple, and more 913 spring green and some 929 pink to the apple at right. Their stems are also further delineated with touches of 912 apple green and 924 crimson red.

Hue and value changes are further emphasized on the tabletop and in the fabric. The tabletop is darkened in the area of the apples, and some 913 spring green is added to suggest the apples' reflections. The fabric's slight roll is better modeled with 924 crimson red and 903 true blue, and, as a final step, a little 921 pale vermilion is applied to the left foreground, and the fabric's edge redefined with 901 indigo blue, 918 orange, and 924 crimson red.

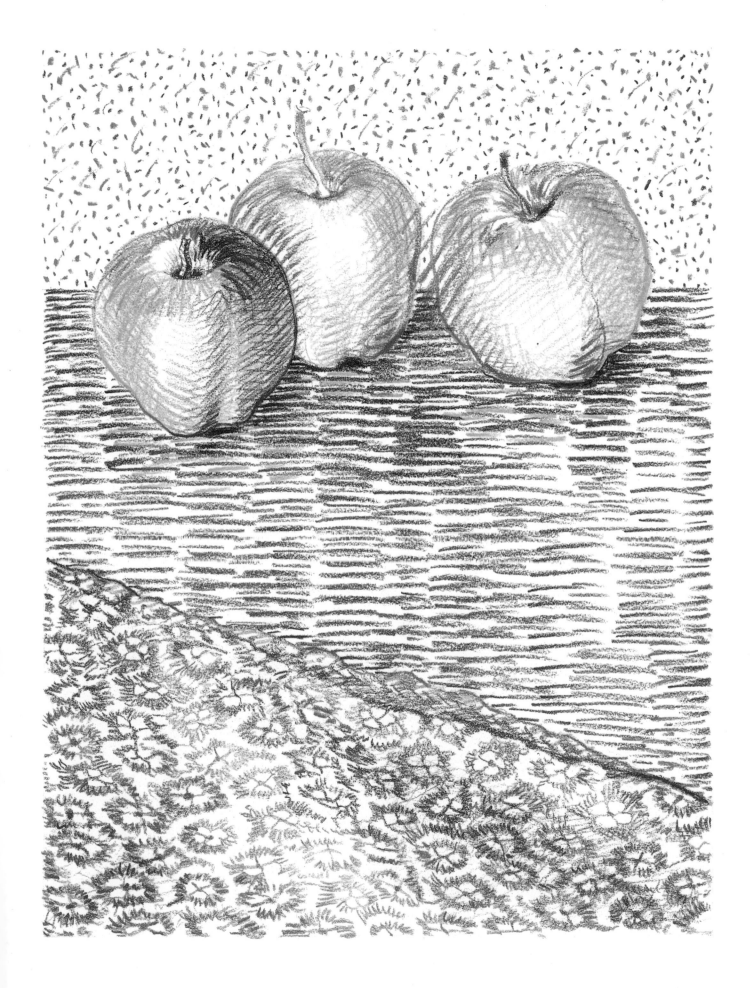

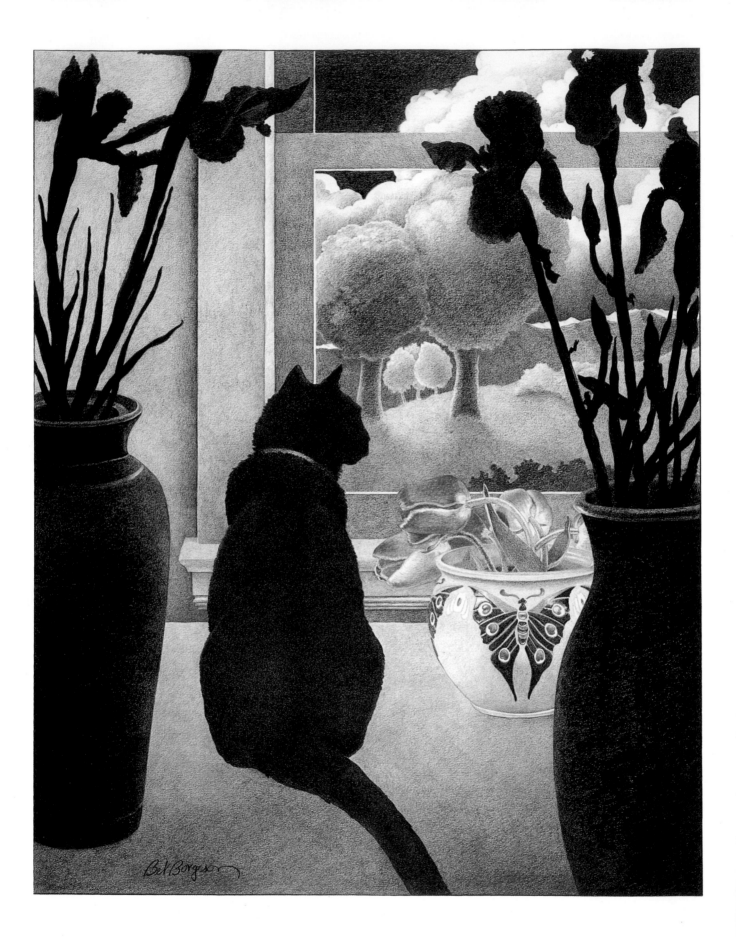

6
Tonal Techniques

Colored pencils truly excel in tonal drawing. In the sense that graphite pencils work best with the linear form of expression, colored pencils work best with the tonal form, or a combination of both.

Tonal drawing refers to the effect produced by pencil strokes applied so closely together and so compactly that they appear to merge. This is done without smudging or rubbing, and the tones achieved in this way lose almost all suggestion of line.

How Tone Is Achieved with Colored Pencils

Tones are made with a colored pencil's point (sharp, dull, or blunt) or with its shaft (the side of the lead). The quality of tone produced can be strongly or subtly influenced by the shape of the pencil's point, as well as by the method in which the pencil is used. A slow and careful stroking with a very fine point, for example, can produce a finely grained tone. A stroke that is fast, but uses a dull point or the pencil's shaft, will yield a much coarser effect.

Colored pencil tones are also influenced by individual temperament. The same pencil in

Bet Borgeson, Silhouettes, *1989. Colored pencil and ink, 19" × 24" (48.3 × 61 cm). Private collection. With colored pencil, ink is often used for outlining. In this piece, however, solid ink areas have been established, then colored pencil applied lightly and tonally over them.*

different hands may produce very different tones, with a range in appearance from loosely vigorous to machinelike.

Pencil Pressure and Paper Surface

As noted earlier, the pressure with which a colored pencil is applied has a great effect on that color's value. A wide scale of tonal values can be expressed for each color by variations in pencil pressure. The only limitation is that each pencil has its own inherent value, which in most cases is what you see when you look at the lead; and it is what determines the maximum dark value available in that pencil.

A paper's surface also plays a critical part in the achievement of colored pencil tones. We have seen how particles of a colored pencil's lead are "filed off" by a medium-grained paper's tooth. This is desirable; it is, in fact, what characterizes it as a medium of texture and makes its unique results possible. When working with tone, the texture and pattern of a paper or drawing surface become strong factors that must be taken into account. These surfaces are readily apparent underneath medium to dark tones, and, similarly, a repeating or obviously patterned surface can become an unexpected and unwanted element in a drawing. On the other hand, a particular surface might be exactly what *is* wanted. So before launching out full-scale on a new or untried paper surface, it is always wise to experiment with the paper surface first and find out what effect it will have on your tonal work.

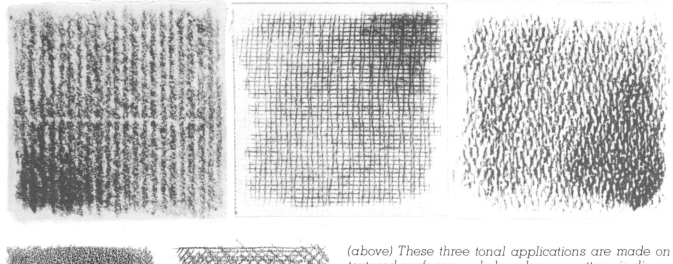

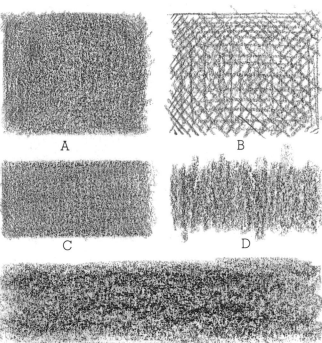

A

B

C

D

E

(above) These three tonal applications are made on textured surfaces and show how a pattern is discernible through the colored pencil tone.

(left) The difference between colored pencil tones achieved with a tonal technique and those made with a linear technique can be seen at A and B. The following three variations of tonal technique are made using: C—a sharp pointed pencil, D—a dull pointed pencil, and E—the pencil's shaft.

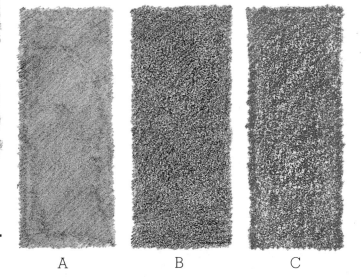

A B C

Besides the instrumental part played by a paper's surface in expressing the character of a tonally applied passage, the hardness or softness of a pencil's lead is also important. In sample A, a 2H graphite pencil shows negligible granular texture due to the relative hardness of its lead. Sample B, made with a Derwent Studio Series colored pencil, shows more texture. Sample C, made with a Prismacolor pencil, which is softer than either of the other two, shows the most texture. All three samples were drawn with sharply pointed pencils on a medium-textured paper.

Layered Tones

Because colored pencils are semiopaque—what we perceive as transparent—the tones made with them are often achieved by layering, the superimposition of one pencil color over another. This can result in more subtle and more complex tones.

The layering of tones with combinations of pencil colors is an exciting and very efficient method of color mixing. For example, choose a particular pencil color at random and then lay down a row of six good-sized patches of tone. Then choose five additional pencil colors, also at random. Lay down a layer of color over five of the color patches, using a different pencil

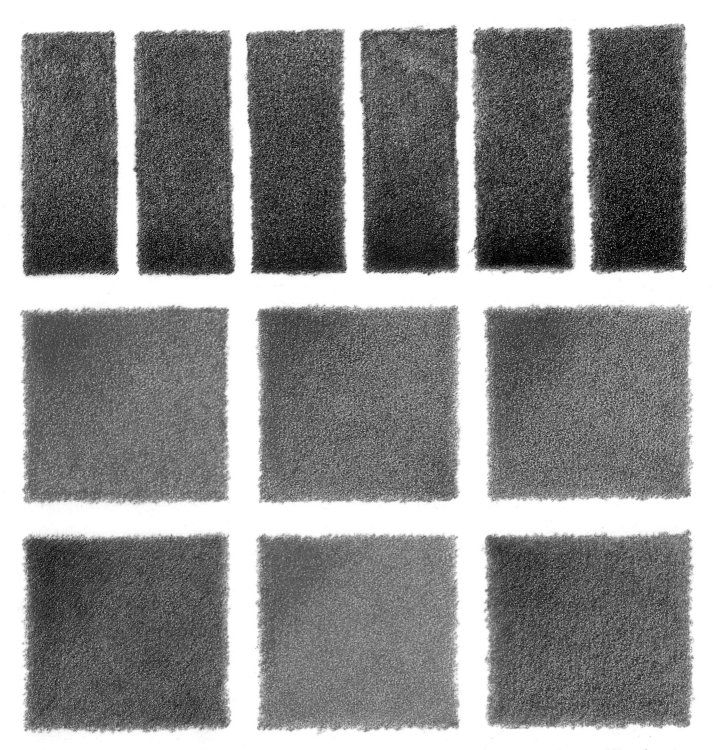

How colors combine can quickly be seen when colors are tonally layered over one another. In the top row, six patches are made with a 933 violet blue. The first patch is left unchanged, and to each of the other five patches a second, randomly chosen hue is applied. These added hues are (reading from left): 924 crimson red, 1007 imperial violet, 929 pink, 911 olive green, and 1017 clay rose.

In the six larger patches, a 903 true blue was applied first to the patch at left center. This patch remains unaltered. To the first patch at its right is

added a near-complementary hue, a 921 pale vermilion, and to the right-hand patch, another near-complementary, 1032 pumpkin orange. These additions of color appear to reduce the intensity of the original color. In the bottom row, the original color's two adjacent colors are added—a 933 violet blue at bottom left, and a 905 aquamarine at bottom center—and to the last patch, both adjacent colors are added. Mixing together adjacent hues will usually subdue an initial color without dulling it.

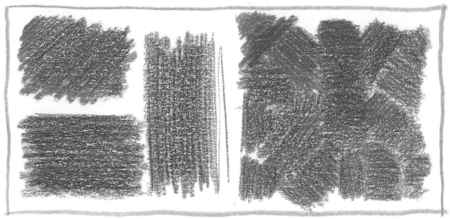

Colored pencil tones can be directional or nondirectional. Compare the nondirectional tone at left with those at right, which are diagonal, horizontal, vertical, and "bundled." In directional tones, a slight linear quality is allowed to remain.

color for each and leaving one patch of color untouched. You are likely to be surprised at how much your constructed tonal colors differ from the unlayered one and at how many ways in which they differ. There is much to discover by experimenting with random changes.

To make your results more predictable, start again with another six patches of the same tone, this time using one of the primary or secondary hues of the spectrum. Leaving one patch unlayered, add a near-complementary color to a second patch, and another near-complementary to a third. To a fourth and a fifth patch add the patch color's adjacent hue on each side, and to the last patch add both these adjacents. Now compare the unlayered patch with the first two layered patches—those with near-complementary colors added—and you will find hues of lessened intensity. The three remaining patches that are layered with analogous colors will look brighter than the unlayered original, or possibly slightly subdued, but no duller. Your experiments with this should convince you that color is dependable.

Direction in Tones

Sometimes a colored pencil tone shows no trace of line or direction. It appears to blossom of its own volition, with delicate gradations

and a look of quiet granularity. It is a tone with an air of elegance. This nondirectional kind of tone is achieved by careful pencil stroking with a fine point, and by changing the direction of these strokes so frequently that no linear quality is developed. For these changes in direction, hand angle is shifted often, or the paper itself is shifted as needed.

However, some colored pencil tones are directional; they reveal an energetic, almost linear thrust. This effect is produced by laying the tones down in a pattern that is consistently diagonal, horizontal, or vertical. This kind of tone can also be characterized by seemingly random changes in direction, or by being organized into "bundles" suggesting a woven texture. A spirited directional tone sometimes gives way to line, resulting in a fusing of linear and tonal techniques.

Handling Tonal Edges

The handling of edges with colored pencils—whether edges of contours or edges of neighboring colors—can be extremely expressive. In art, as well as in life, the edges we see are compelling elements and are probably fundamental to all our visual perceptions. How we handle our edges in drawing not only delineates shape, it imparts to our work a flavor and mood, and ultimately becomes a telling characteristic of our style.

Edges made with colored pencil tones can vary greatly. They can be hard-edged and solidly defined or so fuzzy they appear almost to dissolve, or they can be of a seemingly infinite variety in between these extremes. You can experiment in your own workbook with the handling of these tonal edges. Scrutinize other paintings and drawings with an eye for how these tonal edges have been handled. And as a clue to the solving of edge problems in your own drawing, try to see how an object's form and its position in space will seem to suggest the handling of its edges.

How tonal edges are resolved can be an expressive part of colored pencil drawings. Compare the difference this single factor makes in these two otherwise similar little drawings.

Demonstration:
Flower with Tonal Technique

It is in the subtle gradations of layered tonal effects that colored pencils excel. Our subject this time is a flower, a single peony. Our plan will be to have the flower be the principal player, with only suggestions of foliage in the negative space. To do this we will employ a finely grained and nondirectional tonal technique.

STEP 1. *A few thumbnail roughs work out our composition and suggest a basic color scheme that is a split-complementary of green, red-orange, and red-violet. This initial color scheme, of course, is tentatively dependent on what is needed later. The peony is lightly blocked in on a medium-grained drawing paper with an HB graphite pencil. The complex petals are only sketchily suggested at this point, and because its stem seems too spindly to support the flower's head, a foreground leaf is added to lend visual strength. Background foliage is not laid in with graphite, but will be developed as the drawing progresses.*

STEP 2. *With a 1943 burnt ochre Art Stix—chosen as a near-complementary of the green that will later be layered with it—a tonal layer is applied to the background. Because the result is coarsely grained, the same color of pencil—943 burnt ochre—is then used to reduce the white specks. The pencil is also necessary for applying color into small areas where the Art Stix cannot easily go. This combination yields a swift and finely grained application. The same result could be achieved using just the single pencil, but it would take much longer.*

Applying the burnt ochre to the background firmly delineates the outside edges of the flower, its stem, and its leaf. The graphite contours are progressively erased as these contours are restated with color. This firming up of outside edges suggests additional inside contours for the flower, and these are lightly laid in with more graphite.

STEP 3. *We now add a first underlying layer of tonal color to various parts of the flower. The pencils used for this are: 933 violet blue, for that part of the flower that is farthest back; 931 dark purple, for the core of the flower; and 922 poppy red, for the area most forward. A 911 olive green is used to model the bud jackets.*

Besides setting up spatial structure, these three underlying colors on the flower also delineate the contour edges of the individual petals. This multi-petaled flower is easier to draw than might be thought. It is basically a matter of arranging a color's values to contrast light against dark. The darkest values, and consequently the tones made with heaviest pencil pressure, occur where each petal begins. The color then lightens in value as it spreads toward the petal's edge.

STEP 4. *The top peony leaves in the background are delineated by creating a negative space around them with a layer of 1063 cool grey 50%. The bottom leaves, those farthest forward, are delineated in the same way with a layer of 1059 cool grey 10%. The foreground leaf is also toned with a 911 olive green pencil to indicate a suggestion of modeling.*

STEP 5. *With the drawing's structure thus established, its additional layers of color are tonally added. A 907 peacock green is carefully layered onto the leaves at the top. Again, the pencil is kept sharp and moved in various directions. Abrupt changes in value must be avoided, for these leaves are to be somewhat indistinct and faintly seen. A 911 olive green is applied more loosely to the leaves at the middle and bottom of the drawing. This layering of greens with our original 943 burnt ochre constructs a natural-appearing green of low intensity. In the leaves nearest the bottom, some of the original 943 burnt ochre is allowed to show through—a technique often useful in helping an element seem integrated with its environment. In this case, the leaves seem to emerge from their background.*

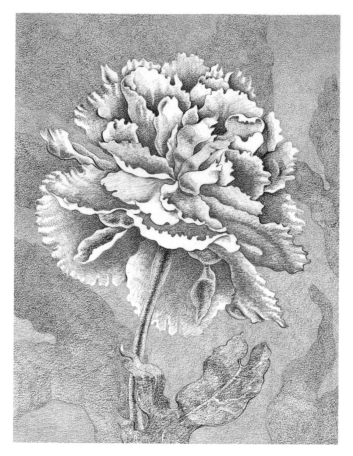

Evaluation: Let's pause now for an objective-as-possible look at how we are doing. One problem appears to be that our peony—which is basically orange-red in color—looks too much as if it is made up of three distinct colors. More 922 poppy red must be worked into all the petal areas, so the red-orange color will dominate.

Some of the leaf tones also seem too ambiguous in some places. A slight crisping and darkening of edges may add needed clarity without overstating them.

(right) **Single Peony #3,** *1992. Colored pencil, 7" × 9¼" (17.8 × 23.5 cm). Courtesy of the artist. To complete the drawing, more 922 poppy red is integrated with all of the flower's petals and 931 dark purple is likewise integrated with a few of the forward petals. Some 916 canary yellow is lightly applied to the flower's petals nearest the front to help project them forward. Tones are generally refined and evened out, and, of particular importance, a firmer gradation of hues and values is made on the flower's two lower back petals with 931 dark purple and 922 poppy red.*

The only remaining adjustment is made to the leaves—a slight darkening and crisping of outside contour edges with the two greens used.

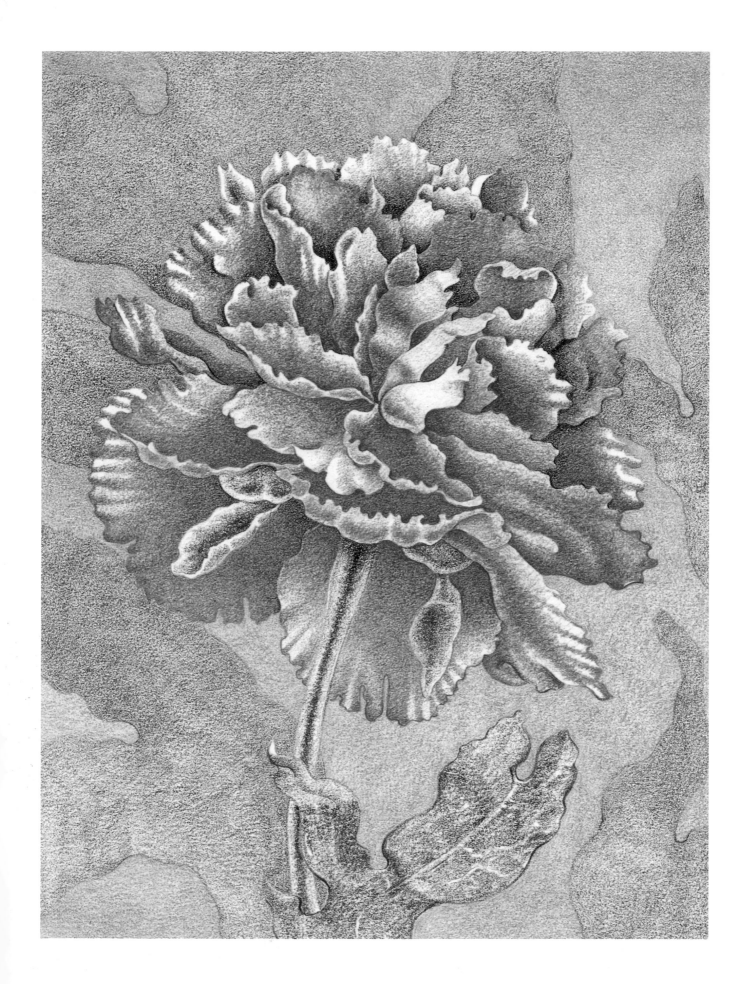

Demonstration:
Flowers on Paper with Gesso Surface

Sometimes a tonal drawing can benefit from a textured surface. An excellent surface of this kind, with a texture more varied than that provided by a machine-patterned paper, can be made with polymer gesso. This is a ready-made product resembling thick cream; it is sold in art supply stores under many brand names. It is fast drying, and a single coat brushed on a sheet of drawing paper yields a textured, flexible, brilliant white surface.

Drawing tonally on this surface emphasizes a brushed texture, which becomes an element in the drawing. This surface also encourages a certain broadness and looseness of line.

STEP 1. *After working out a simple arrangement with thumbnail roughs, the hydrangeas and some of the foliage are lightly blocked in with an HB pencil. As this is to be a fairly spontaneous drawing, developed as we go along, not much drawing with graphite is done at this stage. What is shown here, in fact, is darker than it need be. These lines should be very light, because this time they will not be erased.*

STEP 2. *This is where our drawing really begins. With a 933 violet blue pencil and medium pressure, areas of negative space are tonally drawn to reveal the foliage forms. Drawing this negative space is sometimes the easiest way to see and state these kinds of complex and crowded forms. If we know where our foliage begins (at the ground) and where it ends (in and around the flowers), we can begin by free drawing dark spaces between our not-yet-visible fronds. And because at this point our dark spaces are not very dark, they can be made darker—or can turn into a frond. In this kind of drawing, our composition is still pretty transitional.*

A 929 pink and a 956 lilac are used separately and together to begin modeling the hydrangeas. Much of the gesso surface's brilliant white is left open for the mounding flower heads. By now the brush marks in the gesso are becoming slightly apparent.

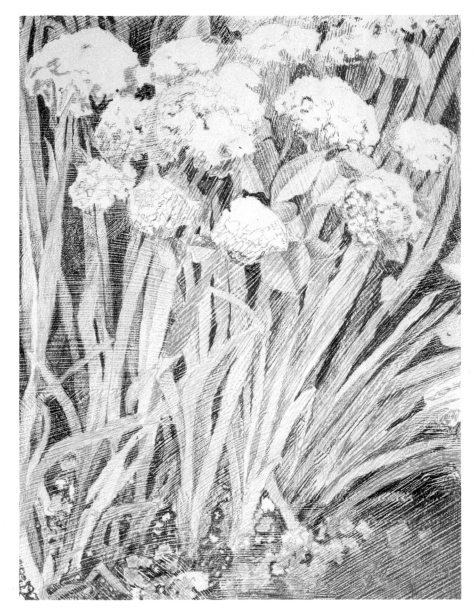

STEP 3. The fronds and leaves are now tonally drawn with four greens: a 910 true green, a 911 olive green, a 912 apple green, and a 913 spring green. These different greens help to refine and differentiate the foliage and to add a suggestion of depth. Spaces between the leaves are darkened with 931 dark purple and more 933 violet blue. Some 911 olive green is also applied with heavy pressure to suggest additional foliage in these spaces. In the lower right foreground, some 903 true blue and a few touches of 910 true green are also added. Although the hydrangea blooms have not been altered, they now project more with the foliage better developed.

Evaluation: This drawing has moved along loosely and fast. So, before we start adding a lot of fussy details, let's pause to consider what really remains to be done.

Two things are quickly apparent: the foliage lacks definition near the lower foreground and in the lower right-hand clump; and, more seriously, the flowers themselves don't quite seem to register. Although their characteristic look was supposed to be rendered loosely, something is lacking. Reviewing the three dimensions of color, one by one, seems to offer a clue. While the general value range of our flowers looks about right—light at their tops and darkening at their rounded sides—their hues are too much the same. This is probably what makes them a bit boring. The intensity of their colors also lacks contrast. So, what our flowers need is more variety of hue and more contrast in intensity.

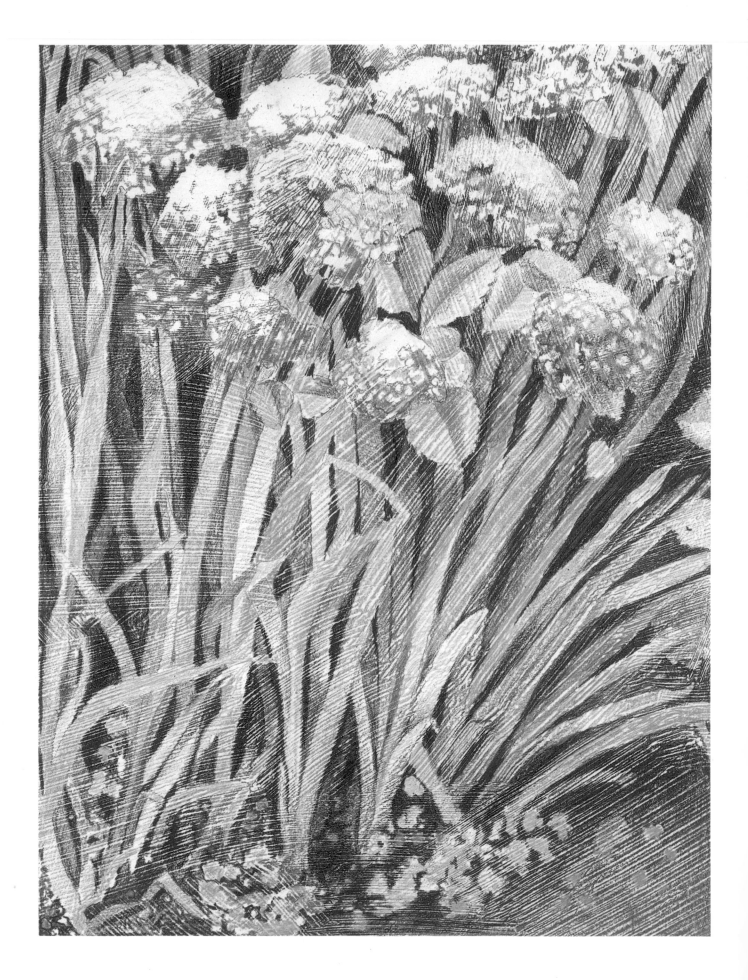

(left) **Garden Hydrangeas,** *1982. Colored pencil on gesso surface, 6⅝″ × 8¾″ (16.8 × 22 cm). Courtesy of Bet Borgeson. A few bright hues are briskly added to the hydrangeas. For the flowers in front, a 923 scarlet lake, a 916 canary yellow, and a 918 orange are used. For the flowers in back, the hues added are a 903 true blue and a 956 lilac. These additions liven them up.*

To further define the foliage where necessary, the linear quality of the gesso texture must be played down. To do this, more greens and some blue and purple are added, applied with sharp pencil points into those grooves of the texture where saturated darks or crisp edges are needed.

The closeup view above shows how pencil tones in this drawing are deposited on the gesso ridges. A sharp pencil point fills in grooves for more color saturation at top center. Note, too, that the flower petals are loosely suggested rather than drawn individually.

7
Constructing Dark Values

More often than not when we think of colored pencil drawings—or drawings made with graphite pencils, for that matter—we think of medium to light values, and a look that suggests lightness of touch. But when a drawing requires a full value range—from the lightest light to deepest black—colored pencils can also deliver convincing dark values.

Among the art-quality colored pencil brands, there are some very good black pencils. In linear work, these black pencils are useful for rendering a smooth and uniform black; in tonal drawing, however, there are better ways of rendering black than merely using black pencil.

Enriching Black with Hue

One way of rendering black in tonal drawing is to overlay it with another hue. For example, the black produced by Prismacolor 935 black is a handsome black. When applied tonally to paper it looks saturated and densely massed. But when it is used within the context of color, it takes on a somewhat deadened look. This disappointing effect of blackness can be avoided—with no loss of the dark value wanted—by overlaying the black tones with color. Some of the hues that work well with black are 937 Tuscan red, 907 peacock green, and 931 dark purple. To see for yourself how a black can be enlivened with no loss of its dark value, try overlaying a 935 black with various colors. You will see these enriched blacks gain in complexity when they take on a suggestion of hue.

(opposite page) Esky Cook, Chocolates III, 1974. Colored pencil on paper, 7¼" × 11" (18 × 28 cm). Courtesy of the artist. In this colored pencil drawing, a wide range of dark values has been rendered with heavy pencil pressure on a medium-grained paper. It is a method of using colored pencil that can sometimes result in a fluid, densely massed look that is more suggestive of painting than of drawing.

In this closeup view above, the densely massed pigment can be clearly seen. Note also how the heavy pencil pressure prevents the paper from showing through.

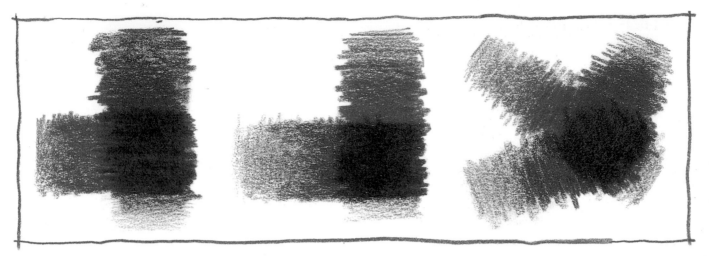

These values that read as black are achieved by using no black. Both the patches at left are constructed by tonally layering the same two hues: 901 indigo blue and 937 Tuscan red. The slight difference in temperature is the result of the red's application over the blue in the first example, and the blue's over the red in the second. In the third example, a 931 dark purple further enriches the near-black of the mixture.

Constructing Colors to Read as Black

A second way of expressing a strong near-black value with colored pencils is by firmly layering two or more dark pencil hues. For example, a 901 indigo blue, tonally layered with a 937 Tuscan red and a 931 dark purple, will produce a tone that is rich and hue-laden, yet one that will read unmistakably as a black.

When dark values are suggested this way, the order in which colors are layered also offers some control of the final mixture's temperature. If in the above mixture, for instance, the 901 indigo blue is layered last, the near-black will convey a cool cast. If the 937 Tuscan red is layered last, the final hue will appear to be warmer.

One advantage of layering dark hues in this way—rather than adding a single hue to a black—is that two or three active colors are put to work rather than only one. Near-blacks constructed by either method, however, will improve your drawing's dark values. Both play a role in building a drawing's structure with color.

The blackness obtainable with a black colored pencil can be seen in the example at left, compared in this case with the blackness of a 2B graphite drawing pencil at right.

In these examples of enriched blacks, a separate hue has been layered over each of three patches of 935 black. These hues are (from bottom) 931 dark purple, 907 peacock green, and 937 Tuscan red.

Avoiding a Common Pitfall

Artists new to colored pencil frequently produce drawings with values clustered in a medium to light key. Such drawings appear light, their color strength insipid. This may, in fact, be the most common pitfall in much of colored pencil work. It is a practice that seems to ignore a full third of the value scale, resulting in the loss of a third of this medium's available richness. It also complicates photographic reproduction. The problem's two major causes:

1. The artist thinks in terms of graphite pencil drawing. Graphite's delicate grays seem a logical part of *all* pencil work. However, colored pencils are tools that, despite superficial resemblances, are very different from all other pencils and can easily express rich, velvety darks.

2. The artist new to colored pencil often believes a dark value can be expressed simply by pressing harder. The fact is that every colored pencil has an inherent value. A Prismacolor 901 indigo blue, for example, is very dark, while a 916 canary yellow is very light. The blue pencil consequently can express any value from dark to light through variations in pressure. The yellow, however, being inherently light in value, cannot yield a dark value, no matter how hard it is pressed.

Because so many colored pencils are manufactured within a medium to light range of values, methods other than pressure must often be used to make these colors darker. Constructing a convincing dark value with a light-valued pencil usually means adding a darker-valued pencil to it.

In a portrait, for instance, of a subject wearing a red shirt, an inexperienced artist might use a 924 crimson red, varying pencil pressure to express the shirt's light and dark values. This would produce a shirt of only light to medium value, however. A better way of showing a fuller and richer value range in the shirt would be to employ darker colors along with the red: a 931 dark purple, perhaps, and a 901 indigo blue (Prismacolor's darkest color).

With some colors, a black colored pencil can be used as a darkener, but caution is needed, as it can also deaden the original color. Generally, a darker-valued pencil in the same hue family yields a more hue-laden dark.

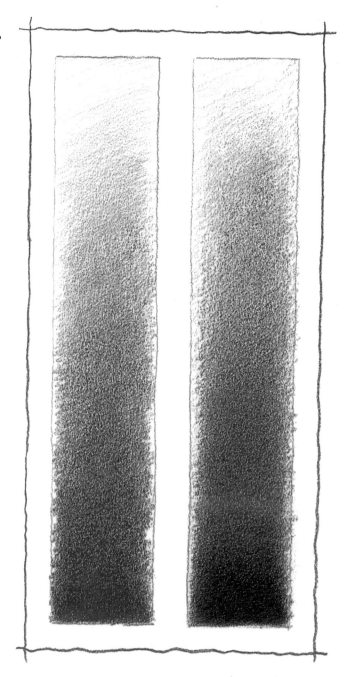

With the colored pencil medium, it is frequently necessary to use more than a single color to achieve a desired dark value. In the value strip at left, a medium-valued 924 crimson red was applied with pencil pressure ranging from very light to very heavy. It is apparent that even with heavy pressure this red pencil's built-in medium value cannot express a convincing dark.

In the correct version of the same red, all values from light to dark are expressed. To accomplish this, pencils of darker value than the original red were also employed at the dark end. First the 924 crimson red was applied, then a 931 dark purple over it, and finally a 901 indigo blue over both of these.

Demonstration:
Tonal Drawing with Near-Blacks

In this drawing, our goal will be to construct tonal values that read as black or near-black, but to do this without using black. Dark values arrived at in this way with colored pencils almost always contain more complexity and richness than those laid in with a neutral black or dark gray. Another advantage of building dark values from colors is that we will have some control of their coolness or warmness of temperature, which can help in making things seem to advance or recede. Our subject this time is a pair of black cats.

STEP 1. *The compositional elements for this drawing are simple—just two cats and a strip of wooden molding. After a few thumbnails to establish the cats' positioning and their overall gesture—very important when there is to be almost no detail except contour—our drawing's three elements are blocked in lightly with an HB pencil on medium-grained paper.*

STEP 2. *For this kind of composition, some control of color structure will be needed to render a convincing feeling of space and depth. Without this, the cat near the molding will appear to float above the cat in the foreground. As an aid toward spatial illusion, the coat of each cat will be constructed to reflect color temperature. We can do this by constructing the fur of each cat with the same two layers of color—901 indigo blue and 937 Tuscan red—but reversing the order of application for each cat. As a beginning, the cat near the molding is initially layered with 937 Tuscan red, and the foreground cat with 901 indigo blue. Various areas of light and dark fur are established. The floral wallpaper is begun with 924 crimson red and 931 dark purple. The floor, which must also serve as an important depth clue, is begun by layering a dark value of 903 true blue and some 931 dark purple near the wooden molding, then merging these downward with a warmer and lighter value of 929 pink.*

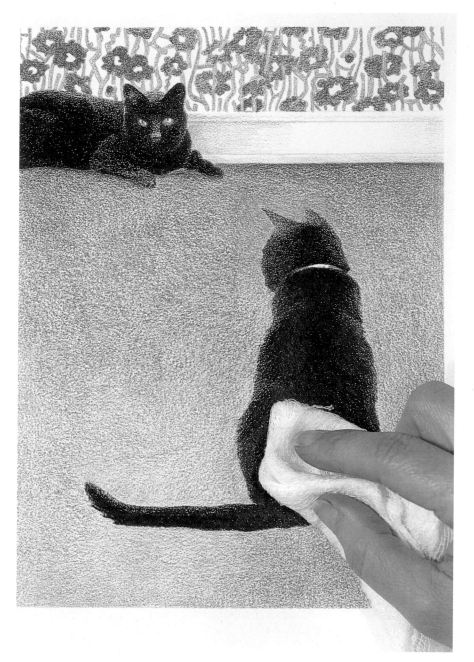

STEP 3. *The spatial structure of the floor is completed by merging the 929 pink into a mixture of 916 canary yellow and 918 orange in the near foreground. The floor is now cool and dark in the background and warm and light in the foreground. The cats are now given their second colors; the background cat is firmly toned with a 901 indigo blue pencil, and the foreground cat with a 937 Tuscan red. Although the cats' contours are modeled with the first color layers, these second layers further model and refine these contours. A touch of 903 true blue is used for one cat's collar, and some 916 canary yellow is used for the other cat's eyes.*

The wallpaper is further developed with more 924 crimson red and 931 dark purple, and its foliage motif is drawn with 912 apple green. The molding is delineated for the first time with 903 true blue, 912 apple green, and a touch of 917 sunburst yellow at its extreme right end. For the molding and wallpaper's lightest values, the white of the paper is preserved.

To inhibit wax bloom on the cats, where the heaviest pressure has been applied, they are rubbed with a soft cheesecloth. This careful rubbing can also eliminate any stroke marks that may remain to catch the light.

Evaluation: *This drawing contains a worry spot, which, characteristically, has not corrected itself and can be traced back to the composition's thumbnail beginnings. In this case, it is the floor. The large area it fills and its lack of complexity give it very little visual interest. Although it serves as an important component in establishing the relative positions of the cats in space, it now also seems somehow too pat—our eye slides by it too fast. It also contains a more specific fault in the foreground, where, by its contrast with the foreground cat, it allows the cat's outstretched tail to seem a central feature of the drawing—an effect that was not intended.*

Since changing the drawing's basic composition is scarcely possible at this point, our best hope lies in improving the "flow" of the floor. Color changes are needed that will add interest to the floor area and also subdue its strong contrast with the foreground cat. Thus, more hue will have to be added.

(right) **Sisters #3,** 1982. Colored pencil, 6⅝″ × 8¾″ (16.8 × 22 cm). Collection of Alan F. and Jodi Mayo Kremen. Complexity and a slight darkening are added to the floor with a 903 true blue pencil and a 932 violet. Some additional 929 pink is also carefully integrated with these colors. Although it is sometimes difficult to layer a dark hue over a firmly applied light hue, this dark violet is successfully layered over the yellow by maintaining a sharp pencil point and using light pencil pressure.

At the center of the floor just under the molding, a 924 crimson red is firmly applied and feathered down to blend. Beneath the background cat, a 903 true blue is blended forward into the pink and violet. Some of this same color is also drawn in under the larger cat to suggest a cast shadow. With these color changes, the floor seems to retain its basic structure of temperature and value but has gained in interest, and the contrast of the floor with the foreground cat is less apparent.

Finally, a little more cast shadow is tonally applied to the molding behind the background cat with 903 true blue and 912 apple green. Some of the 903 true blue is added also to the wallpaper behind the cat, and a bit of the green is added to the cat's eyes.

(right) To ensure that no excess wax will in future bloom to the cats' surfaces, these parts of the drawing are sprayed with fixative. Because a test strip showed that 931 dark purple is intensified by this particular brand of fixative, a shield of tracing paper was cut out to expose only the cats to the fixative spray, and not the floor and wallpaper areas, which contain 931 dark purple.

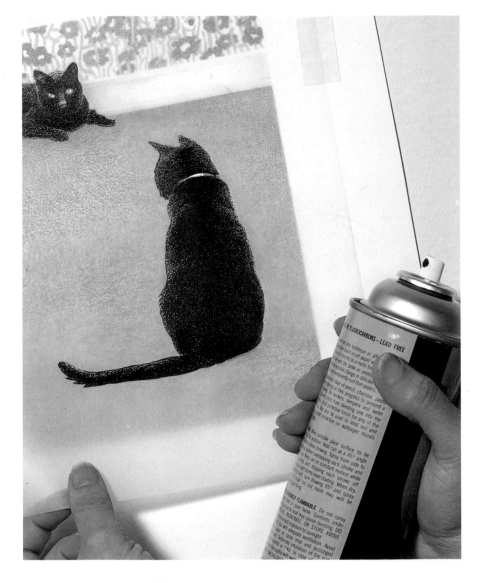

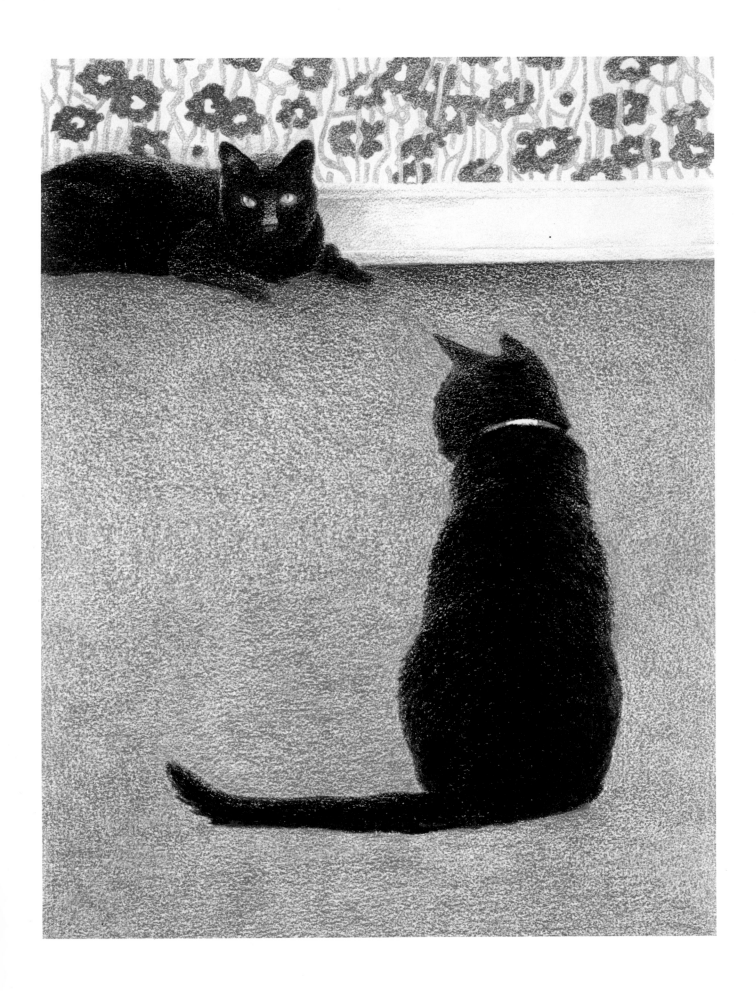

8
Frisket Film Techniques

Some of the most exciting recent advances in the colored pencil medium have been the development of various color-lifting techniques. The reason for the excitement is that these techniques provide a solution to a very vexing problem: how to erase colored pencil satisfactorily.

Previously, artists have had to be content with using a kneaded eraser for lifting color up and away. Because erasing from side to side with a common white or pink eraser is not effective in this waxy medium, the up-and-down motion of a kneaded eraser has worked pretty well. But it is a cumbersome and fatiguing process when the area to be erased is extensive, and it often does not permit control.

As color-lifting techniques are beginning to evolve with the use of frisket films, erasing is becoming a more natural and easier part of the creative colored pencil process. Furthermore, using frisket film makes it possible to draw negatively—to produce light-valued lines—and to create new textures in previously established color areas. Before the advent of this technique, such light elements had to be well thought out before a drawing was begun. Now, many changes can be easily achieved after the fact, bringing added spontaneity to colored pencil work.

(left) Applied color can be easily lifted or removed with low-tack frisket film and a burnisher. Here, a part of the film has been rolled aside, revealing light-valued marks and the tools that produced them (from top): a Kemper double-ball stylus, a colored pencil, and a broad-tipped sculpting tool.

How Frisket Film Lifts Color

Frisket film may already be familiar to you as a masking aid in airbrush and other graphic artwork. The product's name is a generic term, and refers to a low-tack, soft, peel-away film that comes in flat sheets or rolls. Although all frisket film peels away from a backing sheet, various brands may differ in strengths of tackiness.

With colored pencils, however, the film is not used for masking. To erase or lighten color the film is placed over an area tacky side down. The drawing's color and detail can be clearly seen through the film. A burnishing tool is then rubbed over the film, taking care that the film does not wobble or move, and that good contact is maintained while burnishing. The film is then lifted away. If not enough color has been removed, this step can be repeated, moving to a clean area on the film and burnishing once again.

Burnishing Tools

There appears to be no limit to what may be considered a useful burnishing tool. Burnishing is such a basic feature of so many media that a walk through an art supply store will reveal many versions of burnishing tools in many price ranges. Select at least one broad stylus and one ball-type stylus. Colored pencil points at various degrees of sharpness are themselves also useful, particularly when it is critical that you be able to see lines as they are being drawn (rather than after the film is removed).

Demonstration:
Lifting Color and Drawing Negatively with Frisket Film

In art it is often preferable to suggest a feature rather than state it emphatically. In this drawing of cattleyas, the fibrous nature of the flowers' pseudobulbs and leaves can be effectively communicated by drawing negatively with frisket film, after an initial color is already in place.

This demonstration also shows how to lighten a color that has been applied previously. Using frisket film to draw negatively is usually a planned technique. Using it to lighten an area is more often a correction or erasure of a mistakenly applied passage.

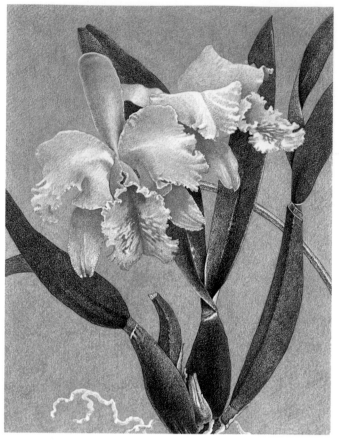

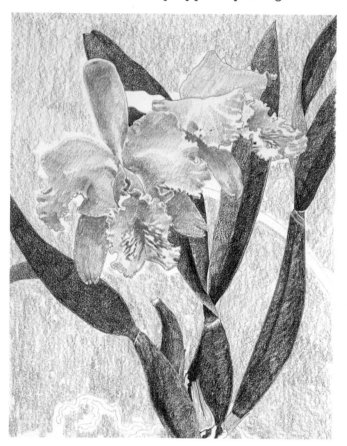

STEP 1. *After graphite guidelines have been transferred to the drawing surface, initial colors are tonally applied. A 931 dark purple with touches of 1003 Spanish orange, and a 916 canary yellow in the throat area, are used to impart color and to begin modeling the flower's form. Single layers of 948 sepia and 911 olive green are used for the pseudobulbs and leaves. A 1902 ultramarine Art Stix is used flat in the negative space. All colors in this step are applied quickly, without refining the resulting coarse texture.*

STEP 2. *The second and final layers of color are applied. A 934 lavender is used to refine the cattleya that faces forward; a duller 931 dark purple is used for the one in profile. For the pseudobulbs and leaves, a 948 sepia is used over the 911 olive green, and vice versa. Just a light wash of 923 scarlet lake is added to the left bulb, and a 909 grass green to the two bulbs at right. A 942 yellow ochre and a 923 scarlet lake are used to suggest a slight modeling of the air roots.*

As these colors are used, values are darkened, edges crisped, and texture reduced. This refining is accomplished by working slowly and keeping pencil points sharp.

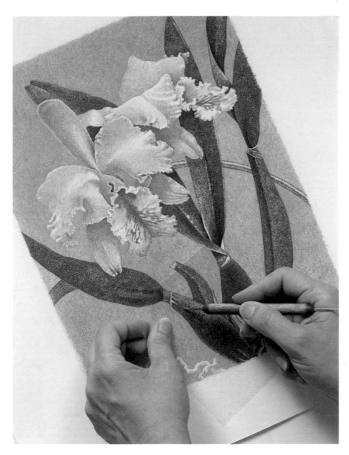

STEP 3. To negatively draw the gnarled effect of the pseudobulbs, frisket film is positioned tacky side down over the area to be worked. Because the entire surface of the film is tacky, care must be taken to avoid burnishing areas accidentally with the mere weight of a hand.

The drawing tool selected is a double-ball stylus that produces a single, clean line. Strokes drawn on the frisket film are firm but not heavy. For maximum lift of color, the frisket film is repositioned and strokes retraced. This drawing process is repeated over the other bulbs. Film and stylus are also used at this time to negatively draw more air roots in the blue negative space.

Note: As film becomes thoroughly covered with color, it should be discarded and replaced with a fresh piece.

In this closeup view of step 3, the result of drawing with a ball-pointed stylus over frisket film can be seen clearly. Line width was varied by first drawing a linear element, moving the film slightly to reveal the line, then redrawing to form thicker areas.

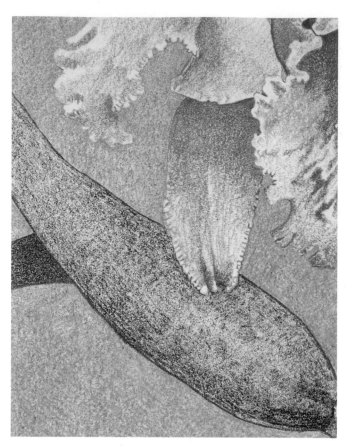

STEP 4. *It now appears that two of the leaves—one at the left and one at the right—should have been drawn much lighter, as they actually represent the reverse sides of the leaves. To correct this—to lift away some of the color—frisket film is placed over the too-dark area. This time, a flat sculpting tool is used as a burnisher. Pushing and pulling its broad end over the film causes the tackiness to lift the color. When using clear film, it is fairly easy to erase only the desired area. Should some nearby negative space be lifted accidentally, however, it can be quickly restated.*

The interesting texture that is produced by lifting away areas of color can be seen clearly in this closeup view of step 4 of one of the leaves. Although most of the lift was accomplished with the broad nib of a sculpting tool, some color was also lifted with a ball-point stylus to suggest a fibrous character. At this point, the leaf is light enough to receive a tonal wash with a lighter, more vivid green.

(right) **Cattleyas and Pseudobulbs,** *1992. Colored pencil, 9½″ × 12½″ (24.1 × 31.8 cm). Courtesy of Bet Borgeson. To complete this drawing, a 913 spring green is applied with a sharpened point to the three now-lightened leaves. A 923 scarlet lake is applied between the new lines on the left bulb, and also somewhat on the right bulb. Edges of the newly created air roots are crisped with a 904 light cerulean blue, and finally a 931 dark purple is used with a very sharp point in the darkest areas of the flowers.*

9
Lifting Color with Tape

When color is to be lifted with precision, delicacy, or good visibility, frisket film is best. But when extensive passages or extremely dense layers of color must be corrected, or a texture created, there is heavier artillery available: drafting or masking tape used with a burnishing tool.

What makes drafting tape (or ordinary masking tape used with care) this medium's "power lifter" is simply the fact that while frisket film has a light tack, the tape has a heavy tack. Otherwise, the technique for using it is much the same. Everything that can be done with frisket film can also be done with masking tape—and often done faster and with greater lifting power.

There are two drawbacks, however. One is that the tape is semiopaque, and lifts must be done almost blindly. The other is the tape's strength. Caution must be used to avoid tearing or lifting away part of the paper's surface. For this reason, it is best to use tape only on multiple layers of color, and on papers resilient enough to withstand this technique.

(opposite page) Bet Borgeson, The Fox and the Old Tree, 1992. Colored pencil on Rising museum board, 19" × 25" (48.3 × 63.5 cm). Collection of the artist. Originally, the entire bluff in this drawing was almost black, with little suggestion of contour or texture. Because the color was dark and densely applied, the error could be corrected only with masking tape. In this case the tape was burnished down at various angles, then lifted to remove most of the darkness. The resulting value changes now suggest a more natural, irregular appearance.

In the detail (left) the strong darks represent remnants of the original color value. To create overall lighter areas, pencil pigment was lifted once. To further develop some highlights, tape was used a second time in just a few areas.

After color was lifted using this technique, no further modification was done. In fact, a few outlines of the tape can still be seen. The various colors visible now are simply lightened versions of the colors used to make the original too-dark values.

Demonstration: Removing Layers of Color with Masking Tape

An understanding of how masking tape can remove previously applied color pencil pigments offers some great advantages for artists working in this medium. Among other things, it opens doors for taking risks with the kind of freedom enjoyed by those working in highly manipulatable media such as oil paints.

To demonstrate some uses of ordinary masking tape in erasing color, we begin with a drawing in progress that is very nearly finished.

STEP 1. Sometimes toward the end of a drawing, a nagging realization begins to surface. Denied at first, then slowly acknowledged, it appears that a dominant color is wrong. Perhaps it connotes too great a monotony, or looks like an anticlimax in an important area.

Let us say that in this drawing it is the multiple layers of yellow-green tablecloth that have got to go. And while we're at it, the brown stripes on the two vases, which now seem too unmodulated, too simplistic, can also stand some adjusting.

These are the kinds of needed corrections that, when they occur at the end of a drawing, often bring on feelings of panic. Fortunately, with good color-lifting techniques, the most difficult part now of making such corrections may be developing the ability to see the need for them. For after this, it becomes a straightforward use of masking tape to lift away color and wax so new colors can be applied.

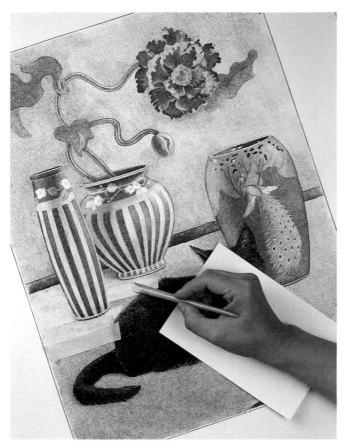

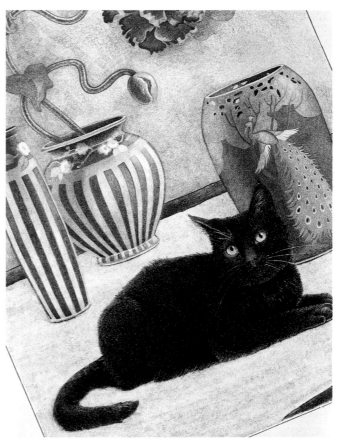

STEP 2. *A short length of tape is positioned over some of the yellow-green color that is to be removed. Resting part of the tape on elements that are to be saved is not a problem, because color will be lifted only where the tape is pressed or burnished down.*

The burnishing tool, a broad-tipped bone stylus, is used with medium pressure. Note also that a piece of scratch paper is placed under my hand to protect the artwork. Care is taken to burnish firmly enough to lift away one or two layers of pigment, but not so hard as to tear paper fibers. Because it is not possible to see clearly through masking tape, some edges of other elements are accidentally lifted, but these can easily be restated later.

This closeup view of step 2 shows how much of the tablecloth's yellow-green color has been removed with the masking tape. The foreground area will also need some additional "taping" to soften unwanted shapes left by pieces of tape. This effect can often be avoided by simply not burnishing to the tape's edges.

The important thing is that enough original color and wax be removed to enable use of different colors. In this case a cool scarlet is the new hue wanted. Had a red pencil merely been layered over the yellow-green, a brown would have been the net result. But removing as much of the original color as we did in this case permits the desired scarlet as a final result.

Note: It is important to remember with this tape technique that as increasing layers of color are removed, revealing more paper, increasing care in burnishing must be used to avoid tearing away the bare paper.

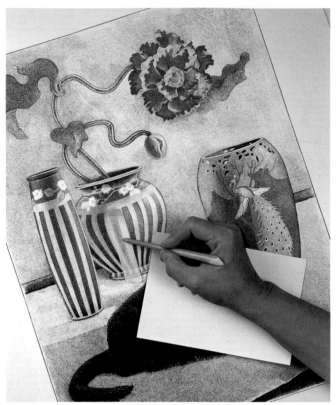

STEP 3. In addition to the color lifted from the tablecloth, a few smaller areas are removed elsewhere. Some irregular shapes of brown are lifted from the striped vases using the point of the stylus to make room for the addition of other, modulating hues that will match the value of the original color.

The cat's collar, barely noticeable in the original version, is lifted in order to lighten its value for better visibility. No additional color is planned for it. Lastly, some of the dark values are lifted away from the peacock vases.

The irregular shapes created by lifting brown stripes can be seen clearly in this closeup view of step 3. Adding new color to these light areas will yield more painterly effects.

(opposite page) **Young Hannah,** 1992. Colored pencil on Rising museum board, 14" × 18½" (35.6 × 47 cm). Courtesy of Bet Borgeson. Adjustments of color have now been made in various areas. A 931 dark purple and a 923 scarlet lake have been layered over the residue of the yellow-green tablecloth. The angle of the cloth's back edge has been altered by using the table's color—a 908 dark green and a 901 indigo blue—to redefine it. A 923 scarlet lake was also lightly applied over the leaves.

A 903 true blue combined with a 931 dark purple, and in some cases a single 929 pink, were applied in various taped areas of the striped vases. The values of these new colors were kept similar to surrounding values so as not to diminish the solidity of the vases.

Finally, a 903 true blue, sharpened to a fine point, was worked into the existing blue-violet of the peacock vase to more clearly establish hue contrast between the vase and the cat and tablecloth.

10
Sgraffito Techniques

The uses of sgraffito—the inscribing of lines with a sharp tool into surfaces such as stone, clay, or wood—are probably as old as art itself. During the Renaissance, sgraffito meant the incising of design into prepared surfaces such as layered and pigmented plaster. The word sgraffito is now used mostly in reference to one or another of the techniques that resemble the original. Examples of modern versions of sgraffito techniques are seen in ceramics and printmaking, as well as in work with crayon, scratchboard, and acrylic and oil paints.

Uses of Sgraffito with Colored Pencils

Colored pencil employs its own variation of sgraffito in two basic ways. One of these is for achieving linear elements in a drawing by the scratching away of pencil material. The other way involves removal of pencil material in order to modify a tonal area.

In the first of these, lines are drawn into colored tones with the point of an X-Acto or similar sharp blade. These lines can be extremely delicate or fairly coarse. They are of lighter value than their surroundings and work best when one or more layers of pencil material have been heavily applied. If the surface is ordinary drawing paper, the lines will reveal the hue of the first layer applied. With a gesso-prepared surface, the scratched lines can also reveal the first color used, or it can even penetrate through to the white gesso underneath.

Sgraffito effects can also be achieved by

When sgraffito techniques are used on paper (opposite page), with either the point or the broad edge of a blade, a hue-stained surface remains. Blade pressure heavy enough to reveal the white of the paper, as seen in the top pair of lines, is likely to tear the paper. More appropriate pressure is seen in the other strokes, the top group made with the point of a blade, the bottom group with a broad edge.

The closeup above shows the effects of sgraffito on a gesso-prepared surface. Firm pressure with the point of a blade (top), as well as with a broad edge (bottom), removes enough pencil material to reveal a whiteness of gesso, yet retains the gesso's original texture.

using a blade's broad edge to scrape away areas of pencil material. This technique results in smooth and modulated tones, or a deliberately mottled or marbled look. In addition, using a blade's broad edge can also serve as a corrective method to remove unwanted layers of pencil material; however, the paper's surface will be altered where this is done.

Although these sgraffito effects depend greatly on practice and skill at using blades and on the kinds of blades used, the techniques are well worth the little practice it takes to learn them. And as you experiment with a lightly held blade, note how scratching into layered tones combines the underlying colors with those remaining at the surface for changes in the total hue effect.

Demonstration:
Red Onions with Sgraffito Technique

Drawing onions is always interesting. Although their shapes are essentially simple spheres, there is sometimes a wealth of subtle hues to be found in their loose and sloughing skins. To see how sgraffito works with colored pencils, let's draw some onions, placing them within a *chiaroscuro* setting made with a sgraffito technique. As this colored pencil method works best with the kind of heavy pencil pressure that produces a fluid look, our drawing this time may end by looking much like a painting.

STEP 1. *From a few small thumbnail sketches, our arrangement of three onions is composed and blocked in with a graphite pencil on an all rag sheet of paper. For sgraffito, we need a paper resilient enough to withstand the layering and scraping it is to endure.*

Colored pencil sgraffito techniques are achieved with a blade point or with the broad edge of a blade. In each case the blade is held as shown, and pencil material is usually inscribed or scraped in a single direction.

STEP 2. *The drawing's background, which is to end as smooth and darkly mottled, is begun by applying a warm hue, in this case a 923 scarlet lake, varying pencil pressure from firm to heavy. The direction of application is also varied. The onions' contours are refined, with additional details such as roots delineated now for the first time. This overall first layer of pencil is to begin the process of staining the paper's surface and flattening its tooth.*

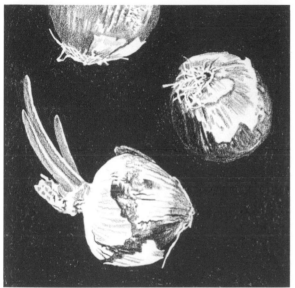

STEP 3. *Individual characteristics of the onions are now tonally drawn in. These red onions are old and sprouting; their surfaces are beginning to shrivel. These kinds of details are assets when drawing from life. They are the landmarks that can serve as a kind of road map to guide us toward accuracy.*

Although each onion is basically red-violet in hue, different first layer hues are used for each to help the drawing's structure, and to suggest individuality. The onion at the top is drawn with a 901 true blue, the middle onion with a 931 dark purple, and the bottom one with a 924 crimson red. The dried roots in each case are suggested with additions of dark values, and a 911 olive green is used to establish the planes of the bottom onion's sprouts.

STEP 4. *A second layer of pencil material—an inherently dark 901 indigo blue—is now applied with heavy pressure to the background area. The purpose of this is to add dark hue, to increase the paper's staining, and to further flatten its tooth.*

Most of the layered background material is now removed using a single-edged razor blade. Scratching of the paper is avoided by working only with the blade's broad edge. The actual amount of pigment removed in this way is arbitrary, depending on the artist's intent. As an end result, the areas in which less pigment is removed will be darker than those areas from which most or all of the pigment has been removed. But these differences in relative lightness and darkness are exactly what create a chiaroscuro effect of softly mottled background tones.

STEP 5. *A third and final layer—this time of 911 olive green—is applied with heavy pressure to the background. Following this, a soft cloth is rubbed gently over the background area to remove some of the excess wax and to minimize pencil stroke impressions. The lights and darks of the area are still visible, but now are softened and blurred. Few, if any, flecks of white paper remain.*

The overall darkness of the background serves now as a key for developing the value range of the onions. To integrate the top onion into its setting, and to better model its form, a 931 dark purple, a 924 crimson red, and a 929 pink are used with medium to light pencil pressure. For the middle onion, 901 indigo blue and 937 Tuscan red are used for its darkest values. Some 923 scarlet lake is applied to its right contour, and a little 929 pink is applied as reflected light on its left side. For the onion at bottom, 931 dark purple is added over some of the original red to modulate hue and value.

Evaluation: *Pausing for a look at our progress, and at possible further strategy, we see that our onions are beginning to be a part of their setting. This is what we want them to be. However, the two most developed onions are starting to suggest another kind of problem. Their lightly applied and somewhat granular tones seem to contrast poorly with the smooth and fluid tones of the background. The difference in character of these smaller elements from the large areas of colored pencil applied with heavy pressure are creating a kind of disunity.*

To maintain our drawing's unity in this regard, the onions should also be drawn with heavy pressure. Instead of building their light and dark values with light and medium pencil pressures, we must this time select pencil hues already containing the values we need, and apply them with full pressure.

Red Onions, *1982. Colored pencil, 6⅝" × 8¾" (16.8 × 22 cm). Courtesy of Bet Borgeson. To finish rendering the onions, colors are added and layered with firm pressure, usually with lighter colors layered over dark. In the bottom onion's shadowed top part, a combination of 903 true blue and 956 lilac are layered and merged with the onion body's 929 pink. For most of the onion's body, 931 dark purple and 924 crimson red are applied heavily, then some areas of 929 pink or 914 cream over that. In the sloughing skin of this onion, 918 orange is applied first, then 914 cream over it, and a suggestion of striping added with 903 true blue and 914 cream. For the crinkled area of loose skin under the sprouts, 923 scarlet lake and 903 true blue are covered with additions of 929 pink and 914 cream. For the sprouts, 910 true green modified with 903 true blue is used, which is covered with a 914 cream where illuminated and with a 956 lilac where shadowed. A bit of 923 scarlet lake is also applied near the top of the tallest sprout.*

On the middle onion, more 923 scarlet lake is added, overlaid with 956 lilac near its left bottom edge and with 929 pink at its right edge. In this onion's root area, 901 indigo blue establishes the darkest value and delineates the root shapes. A 929 pink and 914 cream are also used here and fan out into the areas of loose skin. A little granularity and the paper's white are preserved here as a highlight, and some 918 orange overlaid with 914 cream is additionally worked into this area.

To suggest hairlike roots for the top and bottom onions, a blade point is used to inscribe a few short but very fine lines. More hue is added to all the roots: 903 true blue and 931 dark purple for the top onion, 937 Tuscan red and 916 canary yellow for the middle, and 937 Tuscan red for the bottom. All these are applied with light pressure. Finally, as a precaution against the wax bloom that heavy pencil pressures often cause, the completed drawing is lightly sprayed with an aerosol fixative.

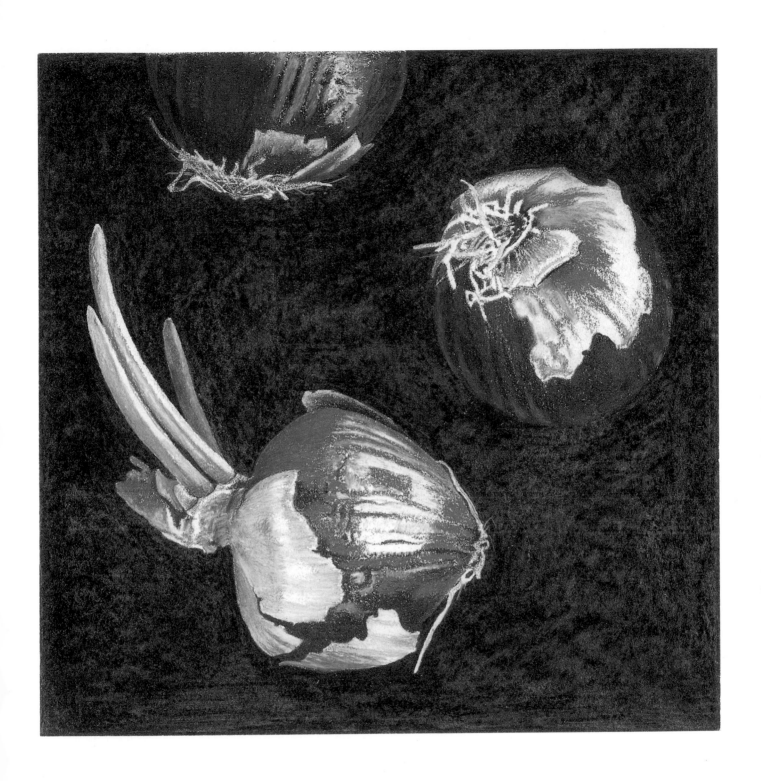

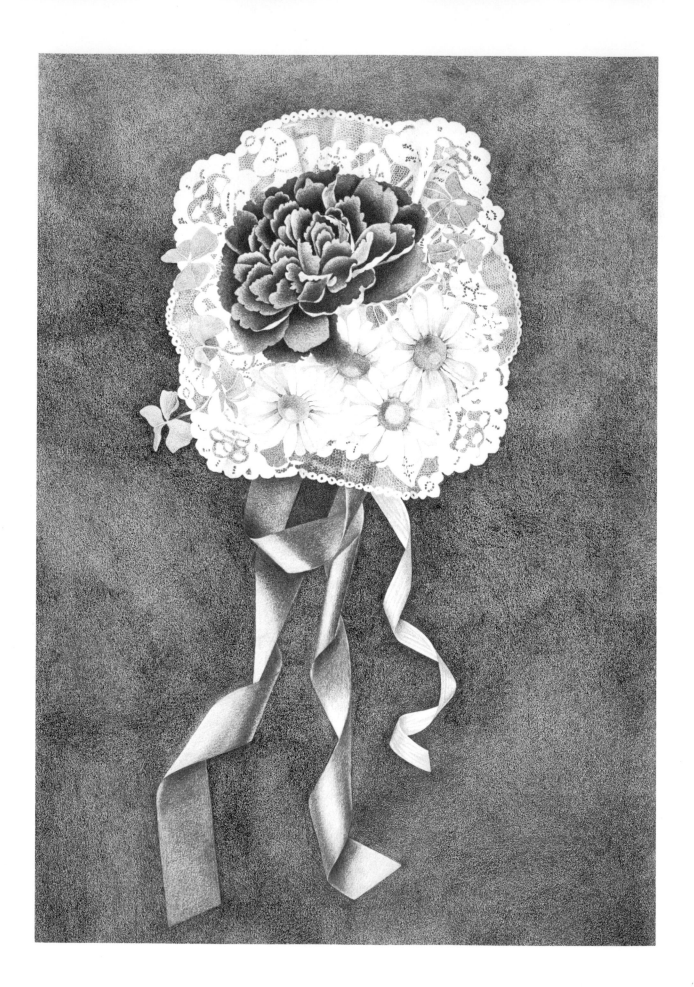

11 Impressed Line Technique

While a colored pencil with a white lead works well enough on colored papers, it cannot render a white line on white paper. Frisket film, masking tape, and sgraffito techniques can remove color in the form of lines, but the result is still not paper-white. A better method for achieving precise and controlled white lines in a colored pencil drawing—lines needed for rendering lace or for the tiny veins in a leaf—is with impressed line technique.

Although essentially a simple process, impressed line technique can produce excellent results. It is done by placing tracing paper over a clean area of the drawing paper where tiny white linear elements are to appear, such as those of a leaf. Then a graphite pencil is used on the tracing paper to firmly impress the leaf's lines onto the drawing paper beneath, taking care not to tear the tracing paper. When the tracing paper is removed, and the colored pencil hues have been tonally applied to the area, the impressed lines will reveal themselves as white in contrast with the surrounding hues. These white lines can then be modified as necessary by adding the appropriate darks. A helpful hint when making these linear impressions: if the lines appear weak because of a harder than average drawing paper, a firmer line can often be obtained by positioning a second, softer sheet under the paper.

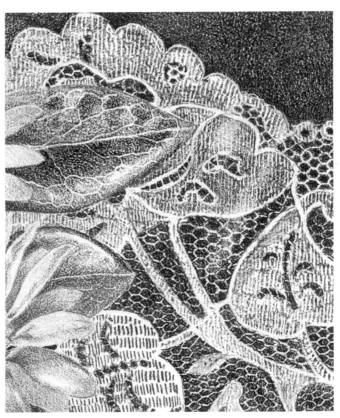

Bet Borgeson, Bride's Bouquet, 1981. Colored pencil on paper, 17" × 26" (43 × 66 cm). Collection of Kurt and Michele Hutton, Portland, Oregon. A central element in this colored pencil drawing—the lace—has actually been rendered from negative space. To do this, impressed line technique was used prior to the layering of colors.

The impressed line technique serves well when controlled linear elements of white or light value are needed. In this detail from a colored pencil drawing, the use of impressed line can be seen in the veins of the leaves and in the lace netting.

Impressed lines are made in a colored pencil drawing by positioning tracing paper over the area to be worked. The lines wanted are firmly drawn on the tracing paper with a graphite pencil. The impressed area of the drawing is then toned with colored pencils to reveal the lines.

(opposite page) Bet Borgeson, *Running Rabbit, 1991.* Colored pencil on Rising museum board, *19½" × 25" (49.5 × 63.5 cm).* Private collection. To suggest the intricate, lacelike effect of the tree branches in this drawing, a combination of sgraffito and impressed line techniques was used. Frisket film was used to create the light modeling on the tree trunks, and masking tape was used to lift and correct the overall hue of the ground.

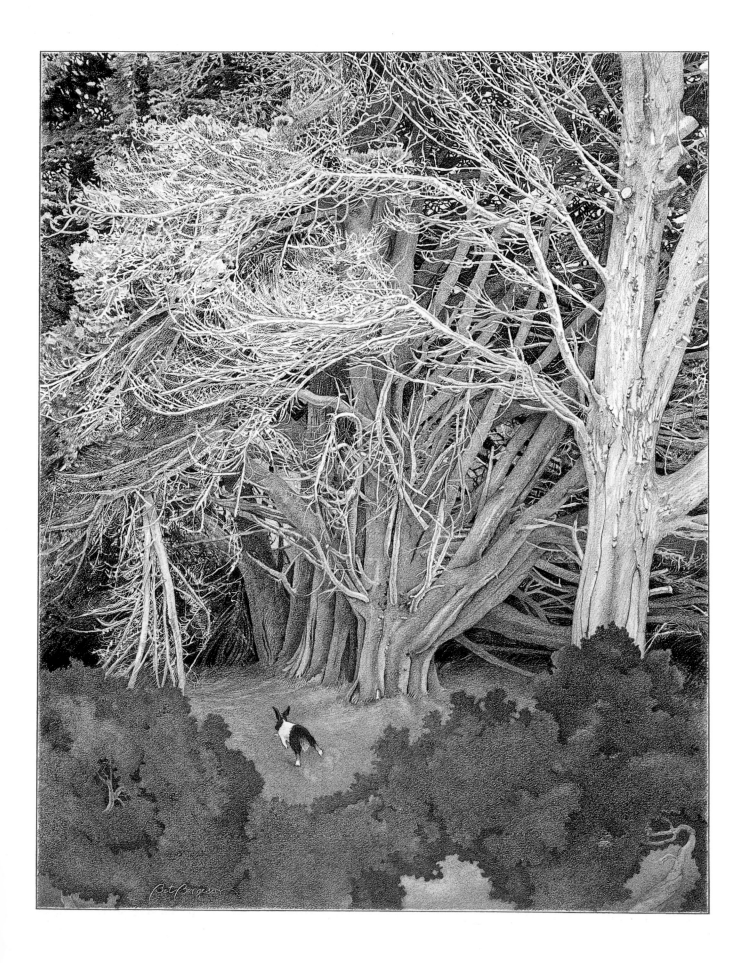

Demonstration:
Tonal Drawing with Impressed Line

A tonal drawing that is to include impressed line technique begins much like any other—with a few thumbnail sketches and a light sketching in with a graphite pencil of the major elements. The drawing paper itself should be fairly soft.

STEP 1. *The basic composition of our drawing—which is to be of a rabbit and some ivy leaves—is blocked in with graphite. Once again, these lines are kept light enough for easy erasure.*

STEP 2. *A 933 violet blue is tonally applied to the negative space of the background. Although a leaf has been planned at top right (as can be seen in our graphite blocking in), it too is covered with the same blue, as its first layer is also to be of 933 violet blue. This leaf will be revealed again when a second color is applied over it.*

The leaves at the bottom, which are to be but pale suggestions of leaves, are drawn with 911 olive green. A 932 violet is used to establish some other key values and is the first layer of color for the rabbit. On the rabbit's lower body, the tonal pencil application is directional, suggesting the nap of its fur. A 929 pink is used to ring the rabbit's eye, and the eye itself is rendered with a 901 indigo blue.

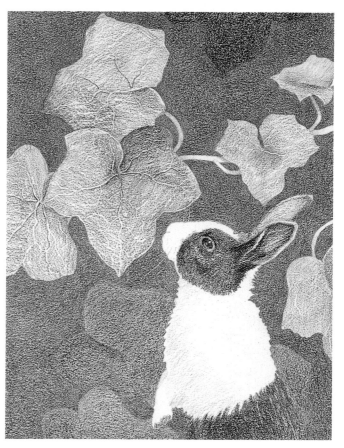

STEP 3. *A sheet of tracing paper is positioned over the ivy leaves that are to receive impressed line work. (The rabbit's whiskers are already impressed.) With a B graphite pencil, and using firm pressure, the characteristic veining of the ivy leaves is drawn on the tracing paper just as if it were being drawn directly onto the drawing paper.*

STEP 4. *To reveal the impressed lines on the drawing, a 932 violet is tonally applied in a variety of directions. A 903 true blue is added over the first blue layer of the background and over the bottom green leaves. A 937 Tuscan red with some 942 yellow ochre is added as a second layer to the rabbit, and the missing leaf at top right is restated with 911 olive green.*

STEP 5. *A second layer of 911 olive green is now tonally added to the main ivy leaves. A kneaded eraser is used to lift away some of the pencil material and create some light values.*

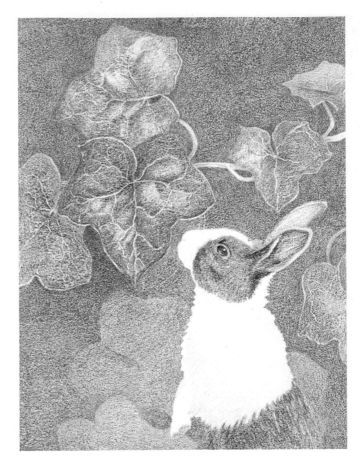

STEP 6. *To more fully develop the lights and darks of the main ivy leaves, 911 olive green, 910 true green, and 909 grass green are added to them. The kneaded eraser has produced some potential highlights, and more medium and dark values are worked into these to suggest the reflective quality of ivy. With many medium-textured papers, a slight irregularity of surface pattern often seems to offer its own clues about where to darken a tone when drawing foliage. A 937 Tuscan red is also used for a little more development of the vine's stem, and as an additional hue in the rabbit's eye.*

Evaluation: *Attempting to see a drawing objectively after working on it with some concentration is never easy. Compositionally, this drawing seems to be going all right. But there is a flatness about it, a certain lack of vitality—and for reasons that seem hard to pin down.*

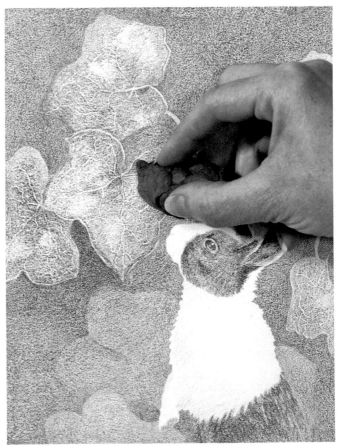

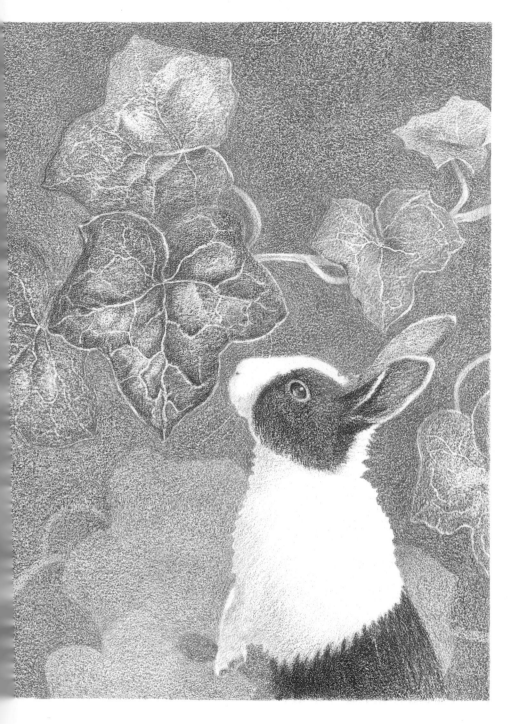

Rabbit and Ivy, *1982. Colored pencil, 6⅝" × 8¾" (16.8 × 22 cm). Courtesy of Bet Borgeson. Contrasts in values—our primary concern—are heightened in several ways. The ivy vine is darkened with additional 911 olive green and 931 dark purple. Values are reversed between the upper right lobe of the center leaf and the area directly behind it. This is done by lifting away the dark green of the center leaf with a kneaded eraser, then further darkening the rear of the leaf. Some warm hues—a 922 poppy red and a 916 canary yellow—are also added to the leaves to help pull them forward.*

The blue background is both lightened and darkened, depending on the values adjoining it. It is darkened with 903 true blue and 933 violet blue where it meets the white of the rabbit. In a few places, a kneaded eraser, pinched to a point, is used to lift away enough blue to suggest vine stems. A line in the leaf near the front of the rabbit is also removed with the kneaded eraser. The blue at the left lower side of the center leaf is also lightened by a lifting away with gentle taps of the eraser.

To add hue and intensity, 922 poppy red and 924 crimson red are applied to the rabbit's fur. A 931 dark purple is used on some of the dark parts, and on the far ear 929 pink and 922 poppy red are applied tonally over a layer of 931 dark purple. Finally, to better develop the rabbit's white fur, some of it is darkened with a combination of 909 grass green, 922 poppy red, and 924 crimson red. A little 922 poppy red is also dotted into its nose.

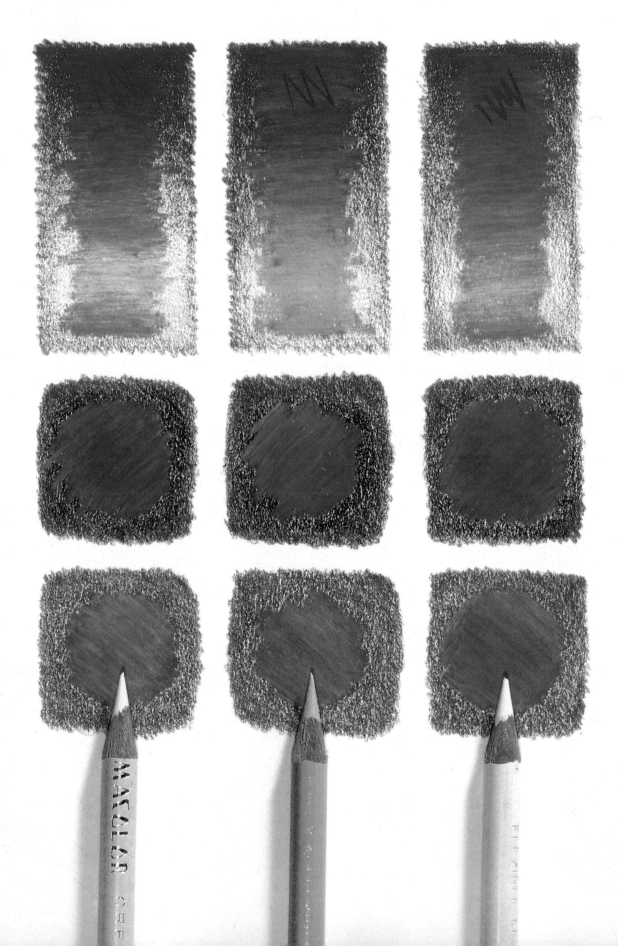

12 Burnishing

A white colored pencil cannot be used to render white unless it is used on a toned or colored paper, but it does have another important use unique to the colored pencil medium: adding a glazed surface effect to a drawing or to parts of a drawing. This technique is called "burnishing," and its effect is unlike that produced by any other method.

How Burnishing Is Done

The burnishing technique is done by applying a white—or a similarly light-valued pencil—with heavy pencil pressure over a previously established tonal area. Among the Prismacolor pencils most suitable for burnishing are 938 white, 914 cream, 1050 warm grey 10%, and 1059 cool grey 10%. The character of the original tonal colors changes as pigment material and paper become tightly compressed. Although the original colors become slightly lightened because of the addition of light-valued pigment, the overall effect is of an increase in color brightness and reflectivity as the original tonal hues are mashed into the paper's surface. This technique can appear to evoke a wet or fluid effect.

In practice, burnishing can be employed at any stage of a drawing. It can be integrated into the initial process of drawing, or it can be used as a final step. Burnishing works well over any colored pencil hue or value. It is most effective, however, when employed over tonal areas rather than those of a loose or linear nature. Also, the less hue contained in the burnishing pencil, the less the original color will be altered. A 938 white pencil, for example, will burnish a color with less change to that color's hue than will a pencil with a similar value, such as a 914 cream, which contains more hue.

Drawing Over Burnished Areas

As an aesthetic option, additional color can be applied over a burnished area. As was discussed in chapter four, in regard to color mixing, a pencil color that is layered over an area of firmly applied white results in a more intense version of that pencil's color.

To see for yourself how burnishing glazes a drawing's surface and appears to heighten color, try it on some sample patches in your own workbook. Start with a few suitable pencils. Apply each of these with heavy pencil pressure over some random samples of single and complex tonal hues.

(opposite page) This illustration shows the slightly different burnishing effects of three light-valued colored pencils on three patches of color. The patches are (from top to bottom row): a single layer of 931 dark purple; a layer of 931 dark purple over a layer of 933 violet blue; and a layer of 918 orange over a layer of 931 dark purple. The pencils used for burnishing are (from left): a 914 cream, a 1059 cool grey 10%, and a 938 white. As can be seen, dark tonal values are least affected by the burnishing pencil's color, while lighter values and single layers are most affected by it.

To see how much or how little the underlying color is affected by the color of the burnishing pencil, experiment with different pencil colors layered over tonal patches of the same hue.

Burnishing is an interesting and useful technique. However, like other techniques that use heavy pencil pressure, it can lead to wax bloom. As a precaution, it is wise to spray burnished areas with a good fixative.

The difference between these two studies based on a textile design is that the version on the left remains as drawn while that on the right has been burnished as a final step with a 938 white pencil. Among the effects of burnishing are an apparent heightening of intensity in some of the colors, a smoothing of overall texture, and a general lightening of values.

Demonstration: Effects of Burnishing

Colored pencil burnishing is a versatile technique. It is also one that must be actually done for a full appreciation of its possibilities for fine manipulation of a drawing's surface. Like most of the techniques that rely on heavy pencil pressures, this one also can give a drawing a painterly quality.

Although the elements in this next drawing are to include a variety of object surfaces, including glazed ceramic ware and a rubbery jade plant, all these surfaces can be burnished—and all with different results.

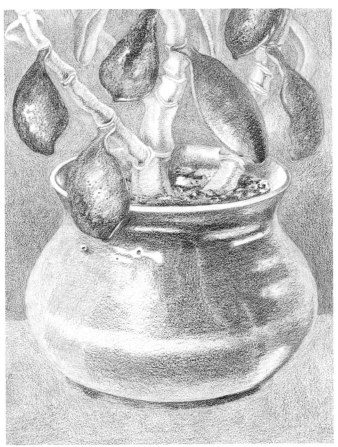

STEP 1. *On a resilient paper, the elements of our drawing's composition are laid in with a graphite pencil. Our dominant color scheme this time will be a primary triad of red, yellow, and blue, with secondary mixtures of orange, violet, and green.*

STEP 2. *Our first tonal hues are applied. Because values will darken as more layers are added, these first layers of color are kept rather light. A 918 orange is used for the tabletop, a 931 dark purple for the background. For the branching stems of the jade plant, a 948 sepia is used as a basic color, combined in some areas with 911 olive green and 932 violet.*

The leaves—developed earlier than some of the other elements because they are not to contain many color layers—are drawn with a 911 olive green and some 903 true blue as reflected light. A few surface pores previously impressed with tracing paper are now revealed.

The dominant hue of the ceramic container is 933 violet blue, with an area at its center toned with 924 crimson red and 922 poppy red to suggest local color changes. A 942 yellow ochre pencil is used at its bottom to serve as a reflection of the tabletop. In several places the white of the paper is preserved for highlights. The soil in the container is suggested with light and dark patches of 937 Tuscan red.

STEP 3. *Additional layers of color are carefully and evenly applied over the first layers. In the background, 918 orange is added to the lower right side of the background. A 929 pink is also used near this area, at the rear of the tabletop, and a 916 canary yellow toward the front. Some 901 indigo blue is added to the soil in the container. To the container itself are added some 931 dark purple and a little 903 true blue.*

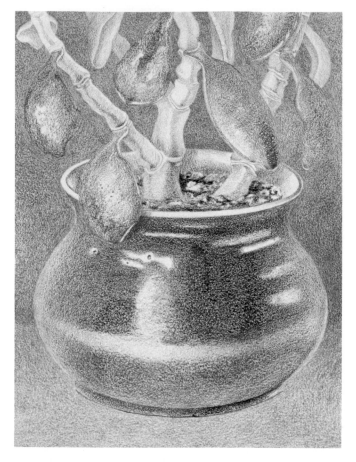

STEP 4. *For the burnishing, our ceramic container is taken as a starting point, and a 938 white used with heavy pressure as a burnishing pencil. Shapes and boundaries of color are disregarded as the white is evenly layered over them. On the leaves and the plant the white is layered loosely over the dark and medium values, but it is not used on the very lightest values. For the background and the tabletop, the 938 white is applied more loosely still, almost linearly. Some of these areas are left unburnished.*

Evaluation: *Among the effects of burnishing is a general overall lightening of values. When burnishing is planned as a final step for a drawing, this can be taken into account beforehand, and the values can be deepened in preparation. When it is used in the process of drawing, however—as we have used it—some values will need restating.*

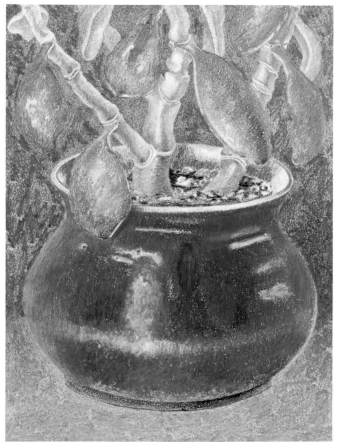

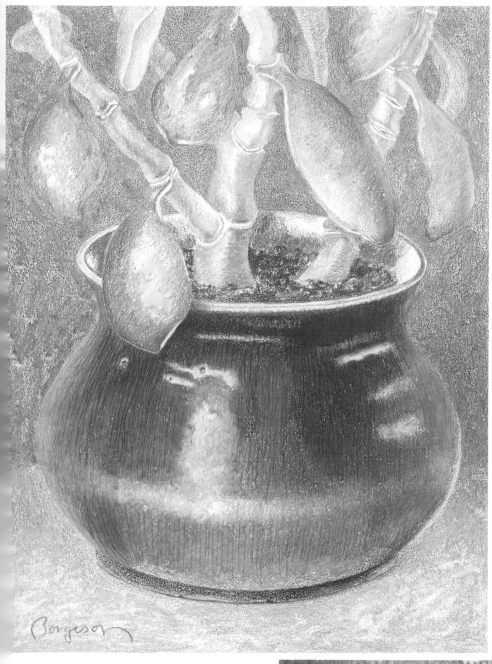

Potted Jade, 1982. Colored pencil, 6⅝″ × 8¾″ (16.8 × 22 cm). Courtesy of Bet Borgeson. Our drawing is completed by adjusting these various value contrasts. To restate the dark values in the container, some 933 violet blue and 924 crimson red are drawn linearly into the burnished tonal areas, following the container's general contours. A similar darkening is given the plant's leaves and stems with 911 olive green and 903 true blue. Some 948 sepia is also added to the leaves, and some 1059 cool grey 10% to the stems. A 937 Tuscan red pencil is lightly applied to the three leaves at the rear to lessen their contrast with the background.

The soil in the container is further developed and darkened with four hues—911 olive green, 924 crimson red, 918 orange, and 932 violet. To lighten the burnished yellow foreground, a kneaded eraser is pressed firmly onto it. This lifts away pencil material not covered by burnishing, but does not change the burnished areas, thus producing an effect of sharp value contrasts.

How vertical colored pencil lines are drawn back into a burnished area can be seen in this enlarged detail. Although these lines serve primarily to darken value, they also reveal a gain in intensity because the burnished surface is slightly more reflective than an unburnished surface.

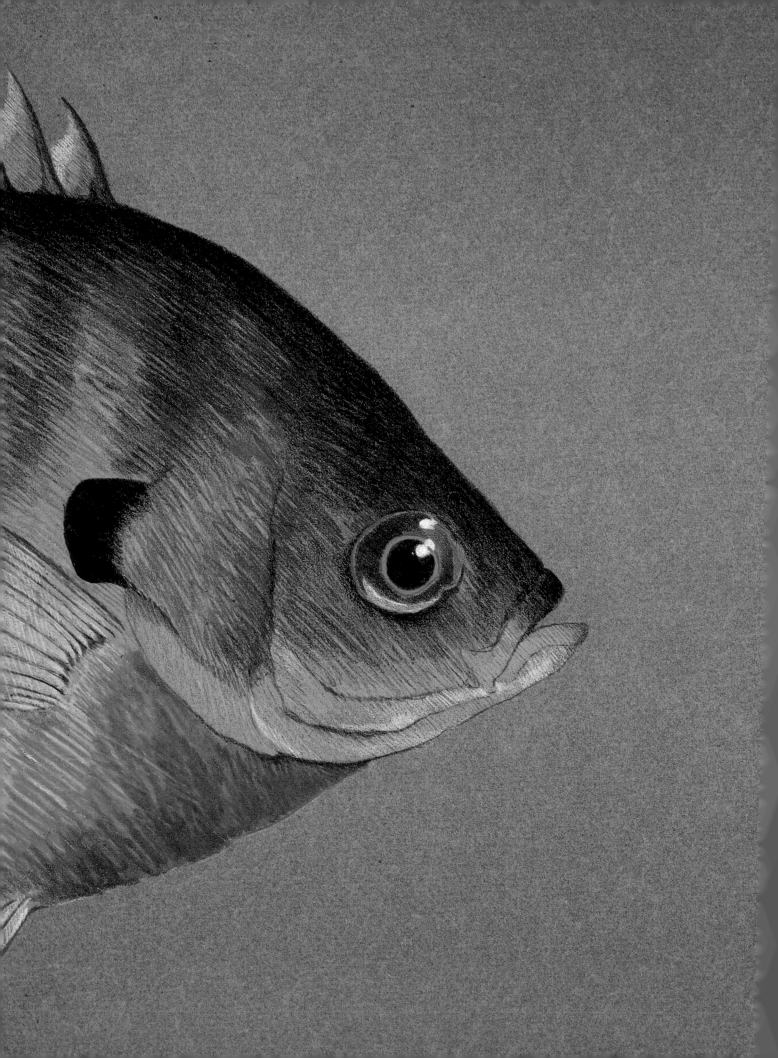

13
Colored Papers

There is an extra excitement about using colored pencils with colored papers. These two materials are related by a natural affinity; and when the combination of paper and pencil is just right, the colors of the pencils glow with a new luminosity.

However, colored and neutral-toned papers vary widely in quality, texture, and in color or tone availability. Because most nonwhite papers gradually fade with exposure to light, it is important that those you select are made of the finest 100% rag and thus likely have a high standard of color fastness. An alternate route to color fastness—when more permanence is desired—is to make your own surface with a watercolor wash on good white paper.

But whether self-made or ready-made, the nonwhite surfaces consistently most compatible with colored pencils are those ranging from colors of low intensity to neutral grays. A paper that is too brightly colored can sometimes work against the purpose of a drawing because it can set up too many limitations in terms of workable color schemes.

Drawing on Colored Surfaces

There are two ways that a colored or toned paper surface functions in drawing. One is to use the nonwhite surface as a middle or near-middle value, where the illusion of a full value

range can be accomplished with as few as two pencil colors—a light and a dark value—and the color of the paper becomes a middle value. This method has a long tradition.

The other way of using a toned or colored paper surface in drawing is to use it as a unifying element. In this case, the color's constancy of hue, value, and intensity serves as a common thread that runs throughout the drawing. It can make a weak drawing look strong. For example, in a landscape drawing, you might use a burnt sienna colored paper as the unifying element, because the color of the paper will read as earth; or similarly in a seascape, you might use a blue-toned paper that will read as water. However, this is a very literal use of color. In that same seascape drawing, you might want to use an orange-toned paper; it would still have the unifying effect but perhaps would result in a more interesting drawing.

Planning Color Schemes with Colored Papers

While the possibilities for color schemes using colored pencils and colored papers are almost limitless—as you will discover when you begin experimenting with them—the following concepts are useful when you are combining colored paper and pencil:

1. Colored pencil almost always appears differently on colored papers than on white paper. This quality makes it essential when

Bob Conge, Sunfish, 1989. Colored pencil on Canson Mi-Teintes paper (steel gray), 14" × 19" (35.6 × 48.3 cm). Courtesy of the artist.

The two basic uses for colored or toned papers are as a middle value (top), and as a unifying element (bottom). In the example at top only two pencils have been used as light and dark values, with the paper itself as a middle value. At bottom, a paper of darker than middle value acts as a common hue and a unifier for the pencils of dark, medium, and light values used.

you are planning for a drawing's color scheme that you test out the particular colors you intend to use beforehand.

2. Colored pencils often need less pencil layering, when combined with the hues of colored papers.

3. Pencil strokes or tones that are kept somewhat open allow a paper's color to better contribute to a color scheme.

4. Bright pencil colors are generally most effective on papers of low intensity; and pencil hues of low intensity work best in monochromatic schemes.

5. Although monochromatic and analogous (adjacent or neighboring) pencil combinations are considered both effective and traditional when using colored paper as a middle value, there are other possibilities. Experimenting can lead you to livelier, more diverse schemes.

6. Colored papers that are darker or lighter than a middle value are particularly effective when the drawing surface functions primarily as a unifying element.

7. Achieving contrast is a vital concept in the planning of color schemes. For example, pencils of light value almost always appear more luminous when used on paper of low intensity and a darker than middle value.

Although personal experimentation and common sense are invaluable aids for planning color schemes on colored papers, it also helps to know which pencils are inherently bright or dull and which are of light, medium, or dark value. In the following list, these properties are categorized for you, using the Prismacolor number assignation and names. But whichever brand of pencils you use, you will find it a real time-saver to assign an inherent value and intensity to each.

Light-value colors:

929 pink	910 true green
918 orange	904 light cerulean blue
917 sunburst yellow	956 lilac
942 yellow ochre	938 white
914 cream	1050 warm grey 10%
916 canary yellow	1059 cool grey 10%
912 apple green	

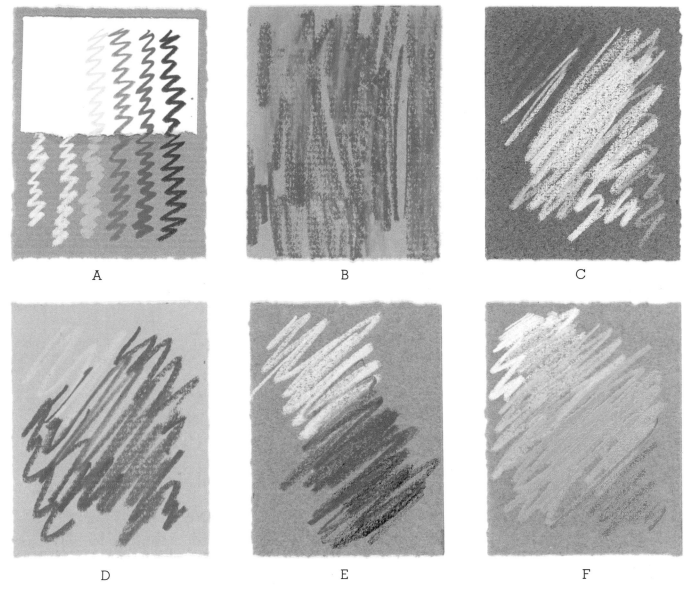

A B C

D E F

The effects of colored pencils on toned or colored papers are similar to those of pastels, but colored pencils generally blend more easily.

When colored pencils are used with nonwhite papers:

A. The pencils—because they are transparent—usually mix with paper's color for a net hue change. A yellow pencil on a blue paper, for example, becomes greenish.

B. An open or loose pencil application allows a paper to contribute to a color scheme.

C. Pencil colors of light value appear more luminous on dark papers.

D. Bright pencil colors work most effectively on papers of low intensity.

E. Paper hue can suggest the pencil hue for a monochromatic color scheme.

F. Paper hue can itself function as color in a scheme. It can combine with analogous pencil colors, for example, to produce a near-complementary scheme.

G. Pencil colors of low intensity can be used very effectively with a colored paper in a monochromatic color scheme.

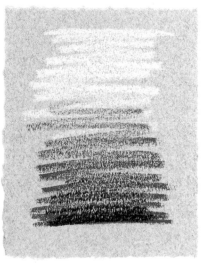

G

Medium-value colors:

923 scarlet lake
924 crimson red
926 carmine red
921 pale vermilion
922 poppy red
943 burnt ochre
1003 Spanish orange

911 olive green
907 peacock green
909 grass green
902 ultramarine
1054 warm grey 50%
1063 cool grey 50%

Dark-value colors:

937 Tuscan red
947 burnt umber
948 sepia
908 dark green
901 indigo blue

933 violet blue
932 violet
931 dark purple
935 black

High-intensity colors:

924 crimson red
926 carmine red
923 scarlet lake
921 pale vermilion
922 poppy red
918 orange
917 sunburst yellow

916 canary yellow
913 spring green
909 grass green
903 true blue
902 ultramarine
933 violet blue
932 violet

Low-intensity colors:

929 pink
937 Tuscan red
943 burnt ochre
947 burnt umber
1003 Spanish orange
942 yellow ochre
948 sepia
914 cream
912 apple green
911 olive green
908 dark green

907 peacock green
901 indigo blue
956 lilac
931 dark purple
935 black
938 white
1050 warm grey 10%
1054 warm grey 50%
1059 cool grey 10%
1063 cool grey 50%

Demonstration: Casual Portrait on Toned Paper

In this use of a toned paper, our purpose will be to have the paper itself serve as the middle value for a casual portrait. We'll use a Strathmore 100 percent rag charcoal paper with a slight surface texture. This is a wonderfully quick way of working, and requires no more than five or six pencils.

STEP 1. With a bright pencil of medium value—a 924 crimson red—a rectangular frame of reference is lightly drawn, along with some proportional guidelines to position our model's features. An inherently dark pencil is selected from our list—a 931 dark purple—and some approximate dark values drawn in with a somewhat sketchy use of line and tone. These dark values are feathered or graded into the middle value represented by the paper, but do not cover the paper enough to become a predominant value. In a casual portrait, most of the attention to modeling is given to specific features of the face, with color and detail lessening as the drawing expands outward.

STEP 2. *Two light-valued pencils—914 cream and a 942 yellow ochre—
are used to add highlights and light values to our drawing's face,
neck, and hair. We now have a full value range expressed. Because a
light source's direction while drawing can drastically alter a reading of
light values on a toned paper, our drawing is also moved around at
this stage for accurate assessments.*

 *Our light values—also graded into the paper's middle—now begin
to suggest where additional modification is needed in the darks.*

(left) **Study of Blond Woman,** 1982. Colored pencil on colored paper, 6⅝" × 8¾" (16.8 × 22 cm). Courtesy of Bet Borgeson. A few warm hues are added. Some 923 scarlet lake is drawn into the hair along with more 942 yellow ochre, and some 929 pink. The dark values on the face's right side are further darkened with a few loose, open strokes of 931 dark purple. Some 929 pink is added to the face and neck. To further suggest the darkest values behind the right side of the neck, and to slightly echo these at the model's left temple and hairline, a 901 indigo blue pencil is used. A final highlight is added to the right upper cheek with a 914 cream over a 942 yellow ochre. A 923 scarlet lake, 929 pink, and 942 yellow ochre are mixed to bring color lower into the drawing and to suggest a fabric drape on the model's shoulder.

In the detail above, you may clearly see the physical presence of this middle-value toned paper in the light and dark colors. This causes the paper to serve as a unifying element. Note also that the very light-valued pencil (914 cream) used on the lip and nose appears luminous on toned paper.

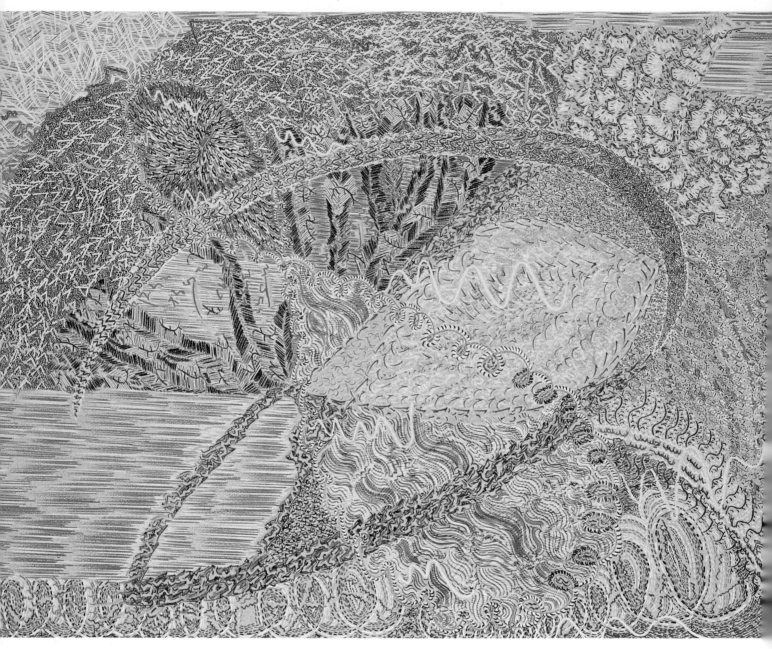

Rosalinda Kolb, In the Ocean of the Infinite, 1979. Colored pencil on gray paper, 20" × 25" (51 × 64 cm). Courtesy of the artist. This energetic linear drawing offers an excellent example of toned paper used primarily as a unifying element rather than as a middle value.

(right) Bob Conge, Self Portrait, 1985. Colored pencil over monoprint on Canson Mi-Teintes paper (dark blue), 10" × 12½" (25.4 × 31.8 cm). Courtesy of the artist. In this drawing, a blue paper of medium value and low intensity helps convey an understated environment for the moody image. A black monoprint establishes the darkest values; then colored pencils, applied loosely and with somewhat rounded points, are used for the light values. This combination of material and technique often yields a result very similar to that of pastel.

14 Liquid Techniques

Until now, we have discussed colored pencils as a *dry* medium. But they can also be used as a *wet* medium, or in combination with other liquid media. This is yet another unique characteristic about them. When colored pencils are used with various liquids they can, in fact, offer the freedom of switching instantly from drawing to painting, with no change in tools, and no loss of artistic momentum.

The liquids used for working with colored pencils may be (depending on pencil type) ordinary tap water, turpentine, watercolor, or felt-tip markers. When liquid is combined with pencil, the speed with which areas of color can be established is greatly increased. At the same time, detail can be retained where wanted, and pencil colors intensified.

There are at present two basic methods of using liquids as solvents with colored pencils, and both depend on the ability of the solvent to partially or completely dissolve the pencil material's binder. One way of doing this is to add turpentine or water to colored pencil lines or tonal areas. This is usually, but not necessarily, done with a watercolor brush. The other method combines the colored pencil material with a *colorless* marker (sometimes called a colorless or clear blender).

There is also an important third method, related to the first two, that combines non-water-soluble colored pencils with a liquid, but does not rely on dissolving the pencil material. This method employs watercolor or colored markers as an underlying drawing or painting to which colored pencils are applied for detail or textural effects.

(opposite page) Julie Rall, On the Lookout *(detail), 1991. Colored pencil and watercolor on 140-lb. hot-pressed Arches watercolor paper, 20″ × 28″ (50.8 × 71.1 cm). Courtesy of the artist. Colored pencil and watercolor are very compatible. In the closeup view, above, of one of the glass plates and fishing lures, the combined technique begins to reveal itself. The watercolor is used first in flat washes to establish colored shapes and forms. After the watercolor has dried, colored pencil is applied in multiple layers with very firm pressure. Little if any paper grain remains visible.*

Using Turpentine or Water

All colored pencils are to some degree turpentine soluble, but only some brands are water soluble. Water-soluble brands include Caran D'Ache Supracolor, Rexel Cumberland Derwent Watercolour, and Mongol. The Prismacolor and Spectracolor brands are among those that are *not* water soluble.

For the look that most closely resembles watercolor or painting, the water-soluble pencils work best. Pencils that are only turpentine soluble also yield a fluid and painterly effect, but they do so with less conviction. Unlike the water-mixed leads, which flow smoothly, the turpentine-mixed kind produce washes of a speckled and slightly clumped look. On the other hand, because the turpentine-mixed pigment dries in less time on the paper than the water-mixed, you can work at a faster pace with a turpentine solvent.

However, the point here is not to discover which of these two solvents is better—because neither is—but only to understand the nature of their differences in solubility and how this influences how you handle a particular type or brand of colored pencil. In either case, there are two basic approaches:

1. *The solvent is added only where needed for spot blending and intensification.* This is done by simply dipping a colored pencil's point into a cup of solvent or into a solvent-saturated cotton ball; a rolled paper stomp (tortillon) or a watercolor brush dipped in solvent can also be used to apply the solvent to the surface. This kind of spot blending is particularly suitable to the more easily controlled turpentine-soluble pencils. They also dry almost instantaneously.

2. *The use of a solvent is integrated into the drawing process from its earliest stages.* In this method, lines or tones are used to establish elements, and brushwork with a solvent used to move around and modify areas of color. Further additions of pencil are then worked into the surface. This is a dynamic way of combining colored pencils with solvents, and one in which distinctions between drawing and painting begin almost to vanish. While water-soluble pencils often excel at this kind of technique because of their easy fluidity, it is by no means limited to them.

An important thing to remember when experimenting with the integrated method of using solvent is, the more colored pencil material that is placed on the paper, the more color you will have for the solvent to liquefy and spread. Likewise, the less pencil on the paper, the less the pigment will spread. This is an important key to gaining control. Also, this method's similarity to working with watercolor requires a paper that is suitable for use with liquid media—thus, a paper not prone to buckling.

Using Colorless Markers

Some manufacturers of felt-tipped art markers also offer unpigmented or colorless markers. They contain only a solvent for liquefying or blending the colored markers. These colorless markers (or blenders) can also dissolve the binder of most colored pencils. In addition, their sturdy felt tips provide the additional friction often needed to freely move the dissolved pencil pigment around the paper.

Colorless markers offer a unique way of working with colored pencils and solvent. With an unpigmented marker, a fine-art-quality pencil can be used with almost the speed and sureness of a felt-tip marker, yet still retain the colored pencil's vitality of color and permanence.

The methods with which unpigmented markers are used with colored pencils are similar to those methods used with water or turpentine. The marker's felt tip can be a swift color intensifier, a means for rapidly lightening or softening an image, or a tool for gaining a more active or gestural surface effect. When using the marker, a sheet of scratch paper is kept nearby to "run out" the picked-up color from the felt tip. One of the advantages of using a colorless marker is that almost any drawing paper can be used with no danger of buckling.

Using Watercolor or Colored Markers Under Colored Pencils

Although using watercolor or colored markers is *not* a process that gains its effect by dissolving the colored pencil's pigmented material, as is the case with colorless markers, they are frequently used for similar effects. Thus, they can also be regarded as a way of combining colored pencils with a liquid medium.

Broad areas of color are usually first established with the watercolors or markers; then pencil colors are laid over the marker or paint color for details of form or texture. The mixing of the semitransparent pencils with the underlying colors adds a quality of luminosity to the pencil colors similar to that gained with a colored or toned paper.

When you begin to experiment with a combined technique, it is important to try different weights and grains of paper for their suitability with both media.

A helpful tip for combining colored pencils with watercolor or markers is to overlay pencil colors that contrast well with the dried liquid color beneath. For example, a light-valued pencil will show well over a dark-valued liquid color passage, as will a pencil of vivid hue saturation over a duller liquid color.

Pencil pressure—whether used firmly to obliterate the paper's grain or varied to exploit the grain—can be determined only by one's own temperament and style. This also applies to the amount of liquid color allowed to show through pencil pigments. Again, one's personal experimentation will be the surest and fastest way of discovering how colors and textures mix for one's own purposes.

Ann Munson, The Morning Watch, 1987. Watercolor and colored pencil on 140-lb. cold-pressed Fabriano 5 Classico paper, 7" × 9" (17.8 × 22.9 cm). Private collection. This small drawing was begun with watercolor and refined with colored pencil. The pencil pressure was kept light to medium, allowing the color and character of the watercolor as well as that of the paper's texture to play major roles in expressing the nature of the subject.

In the example at left above, a solvent brushed into pencil pigment can liquefy colors individually or in layered combinations. In this example the solvent is water, used with pencils designed to be water soluble.

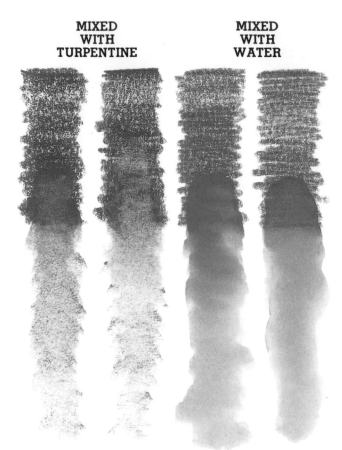

MIXED WITH TURPENTINE

MIXED WITH WATER

Different characteristics of fluidity can be seen in these examples of turpentine- and water-soluble pencils. The pencil pigments of Spectracolor and Prismacolor (left) are turpentine soluble and disperse less evenly than the Caran D'Ache Supracolor and Derwent Watercolour pencils, which are water soluble.

The speckled effect resulting from use of turpentine as a solvent vs. the smoother effect achieved with water can be better seen in this closeup view, below.

Demonstration:
Using Colored Pencils with a Solvent

To see how using colored pencils with a solvent differs from using them dry, let's compare two similar quick sketches. The lily on the left is to be *drawn*, with colored pencils used as a dry medium. Its twin-in-reverse on the right is to be *painted*, with colored pencils used as a wet medium.

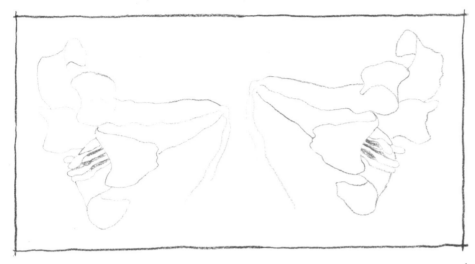

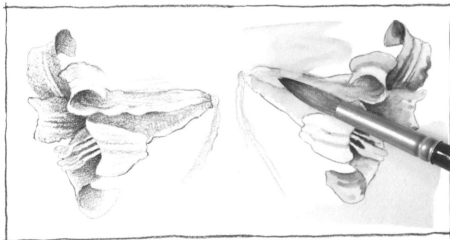

STEP 1. *The beginning for both our sketches is the same, whether we plan to end by drawing or painting it. A sheet of two-ply white Strathmore bristol is our paper surface. Colored and toned papers do not work well with colored pencils as a wet medium, as the solvent creates a dark trail that is confusing to work with.*

Because our painted lily will contain more than solvent accents, we'll use water-soluble pencils for it rather than turpentine-soluble pencils. The Swiss-made Caran D'Ache pencils are a good water-soluble brand. A Caran D'Ache red-orange #070 is used to very lightly block in both flowers on dry paper. A yellow-green #230 is used to define the stems.

STEP 2. *The lily on the left is drawn with four Prismacolor pencils and no solvent. The colors—931 dark purple, 923 scarlet lake, 918 orange, and 916 canary yellow—are applied in tonal layers for the flower, with some 913 spring green added for the stem.*

The lily on the right is handled a little differently. Colored pencil is tonally applied where color is wanted. But this is done rapidly and loosely. Much less pigment is needed when water is to be brushed into it. In the long horizontal body of the lily, for example, two Caran D'Ache pencil colors—a red-orange #070 and a yellow-orange #030—are applied for the darkest area under the curl of the petal. Then a #10 red sable round brush, dipped in water and lightly blotted on a cloth, is used to drag the color from right to left. After this is done, there is still enough wet color in the brush for breaking the linear boundary and pushing some color beyond the lily's contour edge.

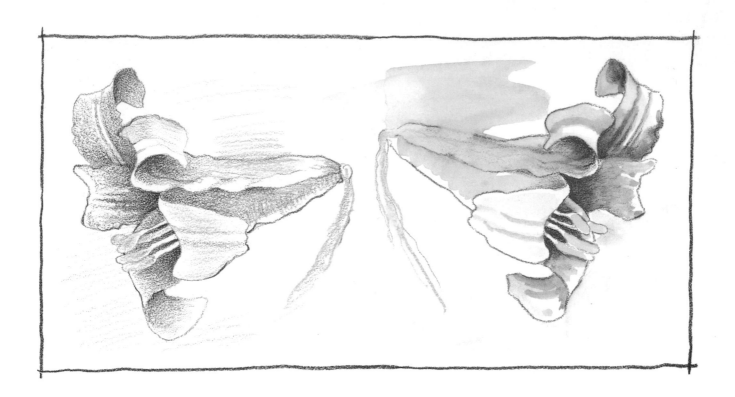

Two Lilies, *1982. Aqueous colored pencil, 6¾″ × 3⅝″ (16.8 × 9 cm).
Courtesy of Bet Borgeson. A few minutes later, the paper is dry
enough to draw back into some of the painted areas. (Had Pris-
macolor and turpentine been used, the wet surface could have
been used or drawn back into immediately, without the few extra
minutes of waiting—but the tones might have been a bit less
smooth.) One advantage of this method over conventional water-
color becomes apparent at this stage: refinements of darkening a
value or crisping an edge can be done with the tip of a pencil that
is exactly the hue of a surrounding color.*

*Comparing these two sketches shows some of the differences be-
tween colored pencils used dry and wet. But did you notice that
the lily in the dry version needed a fourth pencil—a 916 canary
yellow—to achieve an intensity similar to that accomplished with
three pencils in the wet version? And not only does the use of a sol-
vent usually increase color intensity; it also increases speed. The
wet version here took only about half as long to do as the dry.*

A closeup view of the left-hand lily shows the characteristic granular look of colored pencils applied tonally, with no solvent used.

The same area of the other lily shows how colored pencil can be applied dry over a previously washed area to refine or modify a detail or value.

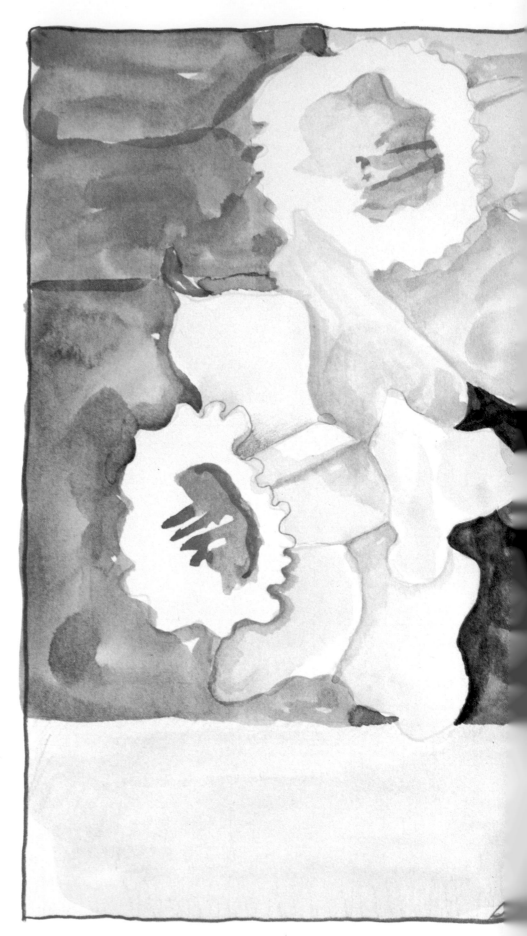

Bet Borgeson, Yellow Daffs, 1982. Aqueous colored pencil on paper, 9" × 12½" (23 × 33 cm). Courtesy of the artist. The flexibility of using colored pencils with brush and a solvent—in this instance Caran D'Ache pencils and water—can be seen in the contrast between the looseness of the flowers and background and the detail of the vase.

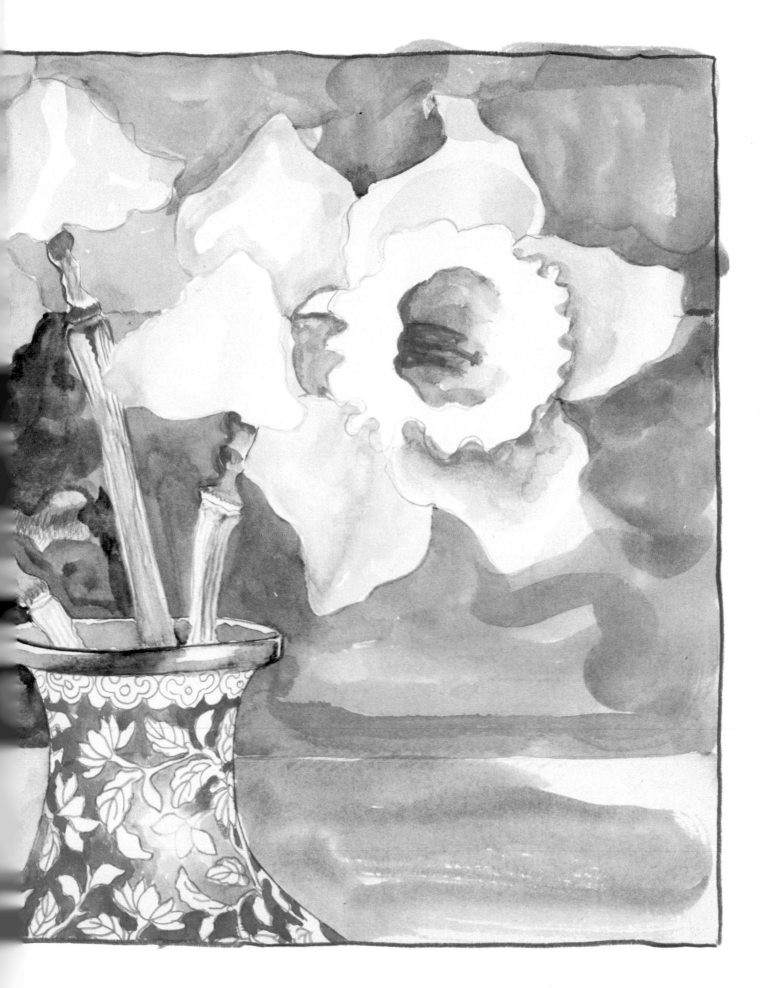

Demonstration:
Colored Pencils and Colorless Blender

Using colored pencils with an unpigmented art marker is unlike any other technique used with this medium. It offers an opportunity to manipulate a painting surface in a particularly gestural and energetic way. There are usually three basic steps in the process.

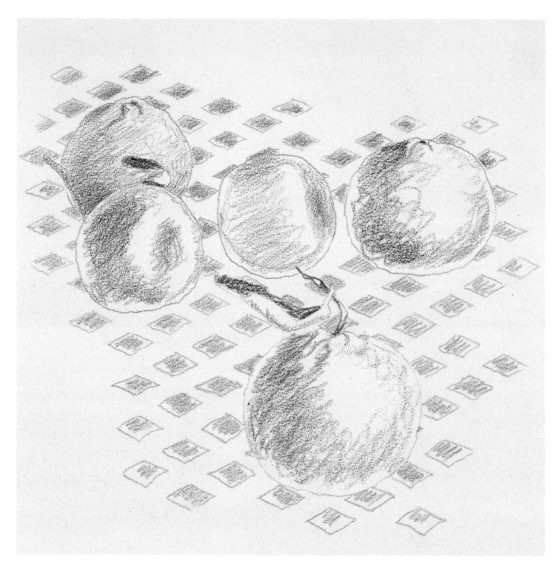

STEP 1. *For this quick study of a few tangelos on a patterned field, Prismacolor pencils are used to rough in the elements on a sheet of regular drawing paper. (Art-quality pencils blend smoothly with colorless markers, and paper buckling is not a problem.) In addition to establishing the relative positioning of our tangelos, these pencil pigments will serve as colors for the unpigmented art marker.*

Layering of different colors at this stage is apparent, but it is done loosely and gesturally. A 949 silver, with some cooler 903 true blue toward the rear, is used for the checkered pattern. The tangelos are established with two basic colors—923 scarlet lake and 918 orange—but with 916 canary yellow and 922 poppy red also used for the forward one. For additional dark values, a 903 true blue is used on the single fruit at the rear, a 911 olive green on the middle row (as well as for stems and leaves), and a 949 silver on the front tangelo.

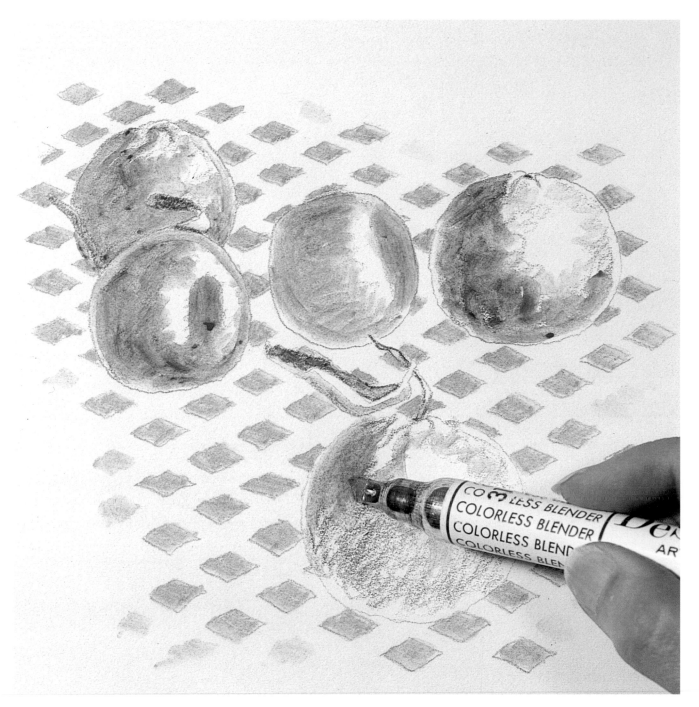

STEP 2. *With an Eberhard Faber #311 colorless blender, and using a gestural stroke, the previously applied colors are blended. Plenty of white paper is allowed to remain, as once it is covered it cannot be recreated. As the colorless marker is moved from one colored element to another, its felt tip is "run-out" on a sheet of scratch paper to restore it to unpigmented solvent. Sometimes, however, a picked up color in the felt tip can first be applied someplace where a light valued wash is needed. Some additional checkered squares were added in this way.*

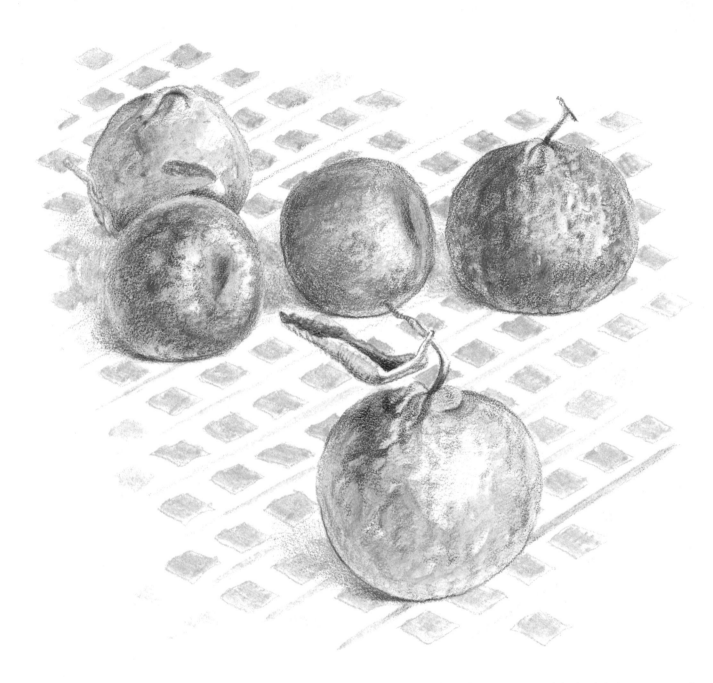

Arrangement of Five Tangelos, *1982. Colored pencil and colorless blender, 6⅝" × 6⅝" (16.8 × 16.8 cm). Courtesy of Bet Borgeson. It is in this third step of using colored pencils and colorless blender that the character of this technique's work is defined — whether it is to be a study or a finished expression. This depends in large part on how far a drawing's refinement can be carried with dry pencils.*

Without having to wait for the surface to dry, more pencil color is now worked into the painted areas. The original pencils are used again, this time to soften and integrate values that model the forms of the fruit. Also, some outside contour edges are crisped and texture is added. A 916 canary yellow is added to the small center tangelo and to the forward one. Some 931 dark purple and 956 lilac are also added to the forward one, and some 948 sepia toned into its stem and leaf as added dark value. Although there is now less white paper showing through, it still plays an important part in achieving sparkle on the fruit surfaces.

Finally, cast shadows are developed by both dry and wet toning beneath and around the fruit with a combination of 949 silver and 903 true blue. To suggest a stripe in the pattern, a line is drawn in with 956 lilac, then softened with the blender.

A closeup view of the front tangelo's shaded side clearly shows
some of the results of this technique's basic steps. The yellowish hue
is 918 orange combined with 916 canary yellow that has been liq-
uefied and manipulated with the colorless blender. The colors of the
922 poppy red, 931 dark purple, and 956 lilac pencils are those ap-
plied dry over the painted area. The firm contour line of 922 poppy
red was added last and not modified with solvent. Bits of white
among the colors remain as the sparkle of bare paper.

15
Blocking In Complex Drawings

Because colored pencils do not erase well, it is a good idea to first lightly block in a drawing with graphite pencil. These graphite lines can then be erased as the drawing progresses.

For a relatively complex drawing, however, or one where the composition is not firmly fixed, this can lead to too much erasing; and the paper's surface tooth can become so eroded that it will cause uneven and patchy colored pencil tones. A better method for achieving a clean finished look with complex work is by transferring the final composition to the surface on which it will actually be drawn in color.

Another less tangible aspect of transferring in colored pencil drawing has less to do with the actual tracing than with attitude. In developing a drawing's idea full-scale, it often becomes clear that something in the composition is wrong or lacking. At the same time, a heavy commitment in time and effort up to this point brings with it the temptation to rationalize errors rather than start over again. This is why working out a drawing on tracing paper first, backed up with a comfortable transfer method, makes it easy and unintimidating to add any changes needed—and without a whole new beginning.

Bet Borgeson, Fable Series: The Fox's Dinner, 1988. Colored pencil, 20″ × 26″ (50.8 × 66 cm). Private collection.

Transfer Methods

There are many ways of transferring the guidelines of a drawing, and most of them work with colored pencils. But sometimes a method's disadvantages for this medium outweigh its advantages. So it is important, as your drawing with colored pencils progresses, that a comfortable method of transferring be found—one suitable to your own temperament and one which can become a smooth part of your own drawing process.

Aside from such mechanical/electrical devices as camera lucidas and opaque projectors—which are relatively expensive and primarily drawing aids—the following are some of the three most commonly used transfer methods:

1. *Pouncing.* In this method, a small cloth bag filled with powdered charcoal or chalk is pounced or patted against a perforated drawing, producing a dotted outline on the sheet of paper beneath it. The disadvantages of this method are that it is time consuming, and its messiness works against the purpose of the whole procedure—a clean and unobtrusive outline on which to base the final drawing.

2. *Transfer paper.* These are papers commercially prepared for transfer use and available in art supply stores; or you can prepare your own papers by coating the back of a sheet of paper with soft pastel, graphite, or charcoal.

This is a very good method for transferring a drawing's outlines to a colored or toned drawing paper, or to a heavy drawing surface.

It is often convenient for me to make my own transfer paper. In its simplest use, a bit of pastel—usually of a contrasting color to the drawing paper—is rubbed on the back of preliminary pencil work, and the desired lines are then retraced with a pencil or pointed tool onto the final drawing surface. Care must be taken, however, to keep these lines faint. Too much

pressure in tracing can leave impressed lines on the drawing surface.

3. *Tracing with translucent light.* This method is very compatible with most colored pencil drawing. In its simplest version, the work to be traced is taped to a sunlit window and the drawing paper held up against it for tracing. This method works in a pinch, but is not very comfortable, and can only be used during daylight hours. Another way—suggested in Bill

A Simple Light Box
The basic ingredients for this box are an 18" (46 cm) fluorescent light and fixture and four pieces of shelving-type wood. The sides are two pieces of (nominal) 1" × 8" (2.5 × 20 cm) wood, 20" (50.8 cm) long, and cut on a slope down to 3" (7.6 cm) high at their front ends. The front is a 1" × 4" (2.5 × 10 cm) piece, 18½" (47 cm) long, and the back a 1" × 6" (2.5 × 15 cm) piece, also 18½" (47 cm) long.

After assembling the box with nails, the front and back pieces are planed to an angle matching the slope of the side pieces. The fluorescent fixture is installed near the bottom edge of the back piece of wood. Another piece of wood (18½", 1" × 4") is installed near the fixture to hold a mat board "reflector."

Gray's *Studio Tips*—is to position a bare-bulbed small lamp on the floor between your chair and the drawing table; and then prop a piece of taped plate glass (with a piece of tracing paper taped under the glass to diffuse the light) between lap and table edge. This will provide you with a lighted work surface.

But the most satisfactory and most practical method of transferring a colored pencil drawing is with a light box designed specifically for this purpose. The problem here is that the large light tables used by commercial studios (and also by photographers and printers) can represent a staggering cost, and even the small portable light boxes seen in art supply stores are often prohibitively expensive.

One answer to this dilemma—and the one I recommend if expense is the problem—is to build a rough but workable portable light box. This is not as difficult as it may seem, as you will see by following the directions below for building a simple light box.

The mat board "reflector" is cut slightly oversized in length to make it curve up toward the box's top front. It is butted against a pair of small nails in the board near the light fixture and rests on another pair of nails near the top edge of the front board. For a brighter light—or for spreading the light better—pieces of crumpled and smoothed-out household aluminum foil can also be taped to the reflector.

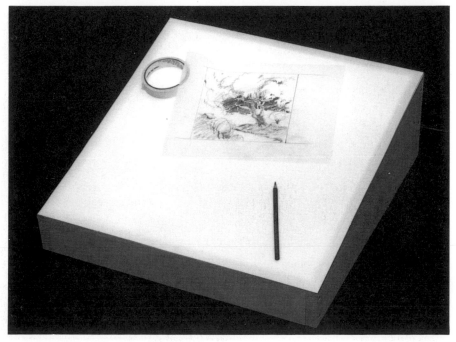

The work surface is a sheet of ⅛" (.32 cm) translucent acrylic, purchased ready-cut to the box's overall size (in this case 20" × 20⅜"/50.8 × 51.6 cm) and fastened in position with masking tape.

Demonstration:
Blocking In a Complex Drawing

Because the colored pencil drawing *Darkling* was to be fairly complex, it was first worked out full scale with the aid of tracing paper and a light box. It offers a good example of what is gained by this process as a next stage after making a few thumbnail sketches of the idea for color and compositional planning.

STEP 1. *At the drawingboard, on a sheet of neutral colored (not yellow) tracing paper, a rectangular frame of reference is drawn with a graphite pencil to the approximate proportions of the best thumbnail composition. Within this rectangle, a basic outline of the planned drawing is worked out at full size. When tracing paper is used rather than drawing paper, the freedom to make plenty of erasures is encouraged, and there is much less temptation to consider the weak areas as "locked-in." Even at this advanced stage of planning, elements can be shifted or changed often in a matter of minutes.*

In this case, the worked-out outline still does not feel quite right. Specifically, the cat as an element now seems too crowded against the top of the drawing. And the leaf at top left further encroaches on the cat.

STEP 2. *To see if these things can be better composed, the drawing is simply cut apart with scissors, and the parts moved around on the light box. The composition immediately seems better with the cat and window sill lowered, and with the encroaching leaf reversed in direction by flopping it over. An extra half-inch of sky above the cat seems to give this element more "breathing" space, and to promise better contrast with the foliage below. With a few bits of masking tape, these elements are taped to one another and to the light box surface in their new positions.*

STEP 3. On a sheet of two-ply drawing paper, the drawing's rectangular frame of reference is repeated, this time adding an extra half-inch at the top for more sky. With the rectangle as a guide, the drawing paper is positioned over and taped to the tracing paper on the light box.

At this point, some of the drawing's outlines can be traced directly with colored pencil. As a general guide toward this, if an element to be traced is simple and straightforward and its surrounding colors already known, then the use of an appropriate pencil color for outlining will save some later erasing. If the line being traced, however, is still not firmly positioned, or if its surrounding color is to be very light in value, a lightly applied graphite pencil will be better because it will later be easy to erase.

STEP 4. *This is an adequate blocking in of the relatively complex outline for Darkling. Between the making of thumbnail sketches and the start of tonally drawing it, the idea has been tested full size and been modified somewhat. I am now ready to begin drawing on a fresh sheet of paper.*

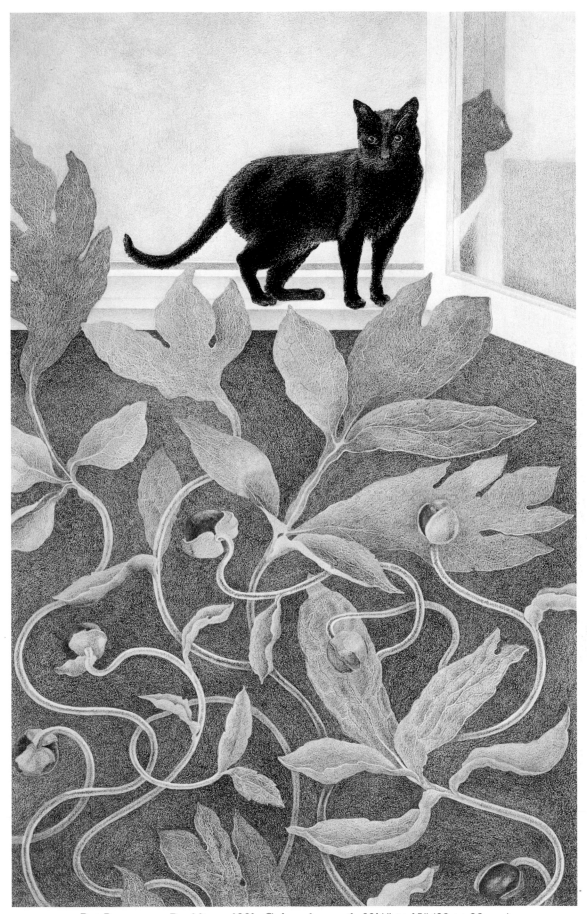

Bet Borgeson, Darkling, 1981. Colored pencil, 23½″ × 15″ (60 × 38 cm).

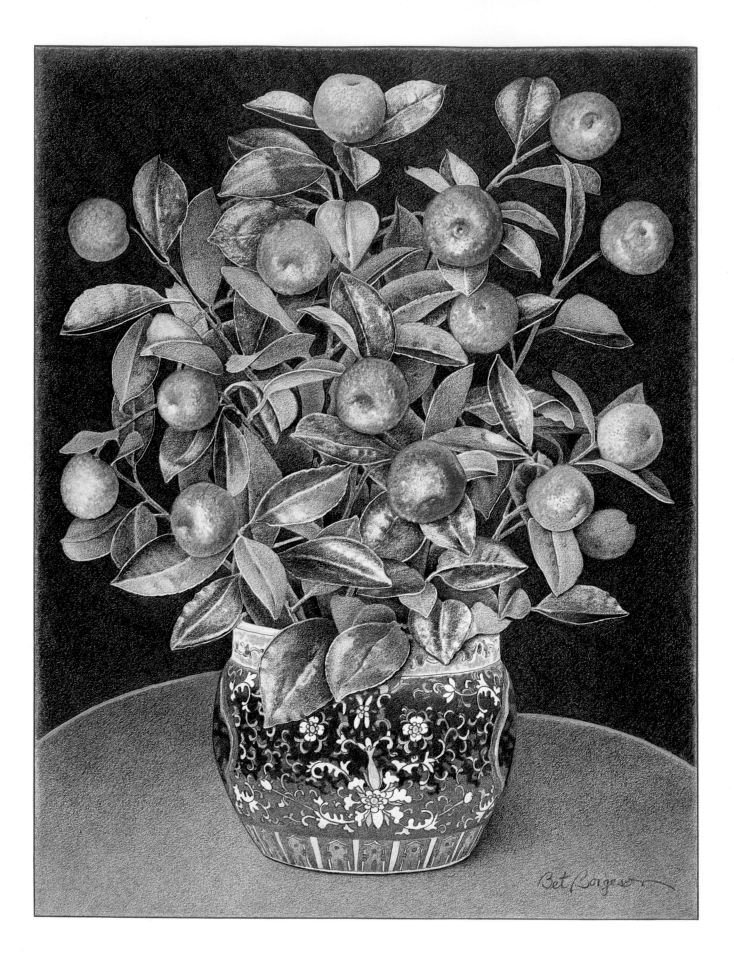

Bet Borgeson

16
Preserving Finished Artwork

In order to adequately protect and preserve colored pencil work, it is important to have an understanding of what kind of problems may develop. The two possible sources of untimely deterioration can be categorized as internal and external causes. The internal refers to deterioration that originates within the pencils or the paper, which ultimately jeopardizes the drawing on that paper. External causes are environmental factors that affect both the artwork and the paper.

Internal Deterioration

The chances of ensuring a long life for a colored pencil drawing are greatly increased by using 100 percent rag paper made with virgin cotton and alpha cellulose or paper formulated to possess a neutral pH. High-quality, non-acidic rag papers are designed for permanence because during the manufacturing process they have been kept free of ingredients or processes known to lead to deterioration.

Another important way to extend the life of colored pencil work is to use only those pencil brands that are known to have the highest degree of resistance to fading when exposed to sunlight or to ultraviolet light rays. This quality of "lightfastness" varies among the colored pencil brands and is dependent on how they are manufactured and on their intended uses.

Bet Borgeson, Dwarf Orange Tree, 1991. Colored pencil, 14½" × 19" (36.8 × 48.3 cm). Courtesy of the artist.

Ensuring a long life for colored pencil work begins with a drawing's earliest stages. This means using only fine art quality pencils, a good rag paper, and a protective sheet of paper between hand and drawing surface.

Whether or not the various brands of colored pencils are intended for fine-art use can usually be quickly determined by product information available from their manufacturers or from display information on view where they are sold. Those colored pencils intended for grade school and other "temporary" applications quite often—and quite justifiably—are not resistant to fading.

External Deterioration

The external factors affecting the longevity of colored pencil work involve its handling, its matting and framing, and its physical environment. In this regard, the best way to protect a work of art is to protect the paper that it is drawn on. Specific suggestions for preventing or minimizing damage from external sources appear in the chart on pp. 140–141.

How to Protect Colored Pencil Work

Here for quick reference are some of the ways of protecting colored pencil work from deterioration. The minimal safeguards are applicable to all such work; the additional safeguards are recommended for work preservation regarded as "archival."

HANDLING

Minimal Safeguards:

Keep hands clean and oil free.

Use fixative (after testing) to inhibit wax bloom.

Do not roll drawing for storage or mailing.

Open mats only from outside edges.

Additional Safeguards:

To avoid damage to paper fibers, use both hands when lifting matted/unmatted work.

Mat finished work as soon as possible after completion.

Use nonacid tissue barrier between unmatted drawings.

Store in wooden, not metal, drawers or containers.

HUMIDITY
(Excessive humidity can cause mold, or "foxing.")

Minimal Safeguards:

Do not store artwork in damp basement or sub-level room.

Do not frame colored pencil artwork in contact with glass.

Additional Safeguards:

Do not store artwork directly on floor.

Hang artwork on internal not perimeter walls.

Maintain humidity between 50–70 percent.

Do not leave artwork in an unventilated house or room for extended periods of time.

HEAT

Minimal Safeguards:

Comfortable room temperature is adequate.

Never use dry mount or heat-sealing methods for colored pencil work.

Additional Safeguards:

Do not hang artwork over fireplace, heater, heat register, or radiator.

For transportation by car or truck, pack and ventilate colored pencil artwork carefully.

Frame with clear acrylic rather than glass, for better ventilation from heat changes and for protection from possible moisture condensation.

LIGHT

(All light fades artwork on paper. Less light means less fading.
Ultraviolet light also causes paper deterioration.)

Minimal Safeguards:

Never hang artwork in direct sunlight.

Use only colored pencils of fine art quality, consisting of permanent pigments that are designed to be light resistant.

Do not hang artwork facing a window.

Additional Safeguards:

Use only tungsten as a work light, and do not leave artificial light on drawing for extended periods.

Avoid, when possible, exposure to fluorescent lighting, which is a source of ultraviolet light.

Keep viewing light level down to that needed for comfortable reading.

Frame with clear acrylic formulated for screening out ultraviolet light.

AIR POLLUTION

(Sulfur dioxide can cause paper deterioration.)

Minimal Safeguards:

The best protection is proper framing.

Additional Safeguards:

Keep artwork in air-conditioned environment.

INSECTS

(The insect enemies of artwork are termites,
silverfish, cockroaches, and woodworms.)

Minimal Safeguards:

Regularly inspect and clean framed or stored artwork.

MATTING AND FRAMING

Minimal Safeguards:

Use mat board heavy enough to adequately support artwork, preferably good quality mat board designed for this purpose.

Wipe away oils (from manufacturing process) from inside sectional metal frames before inserting matted work and glass.

Additional Safeguards:

Use only acid-free matting materials.

Never use chemical or synthetic tapes and glues, rubber cement, or metal staples.

Artwork must not rest directly against the wood or metal of a frame.

The backs of framed pictures should be sealed with a gummed wrapping tape.

Index